AQA

Artists'
Questions
Answered
Watercolour Pencils

HILARY LEIGH

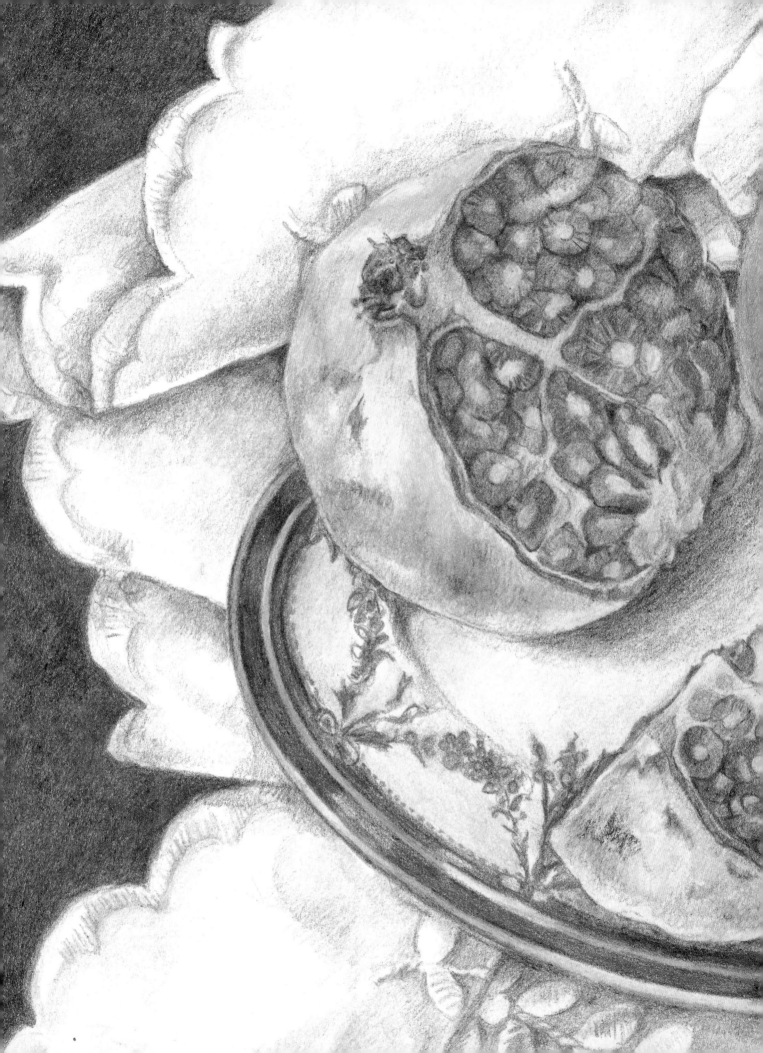

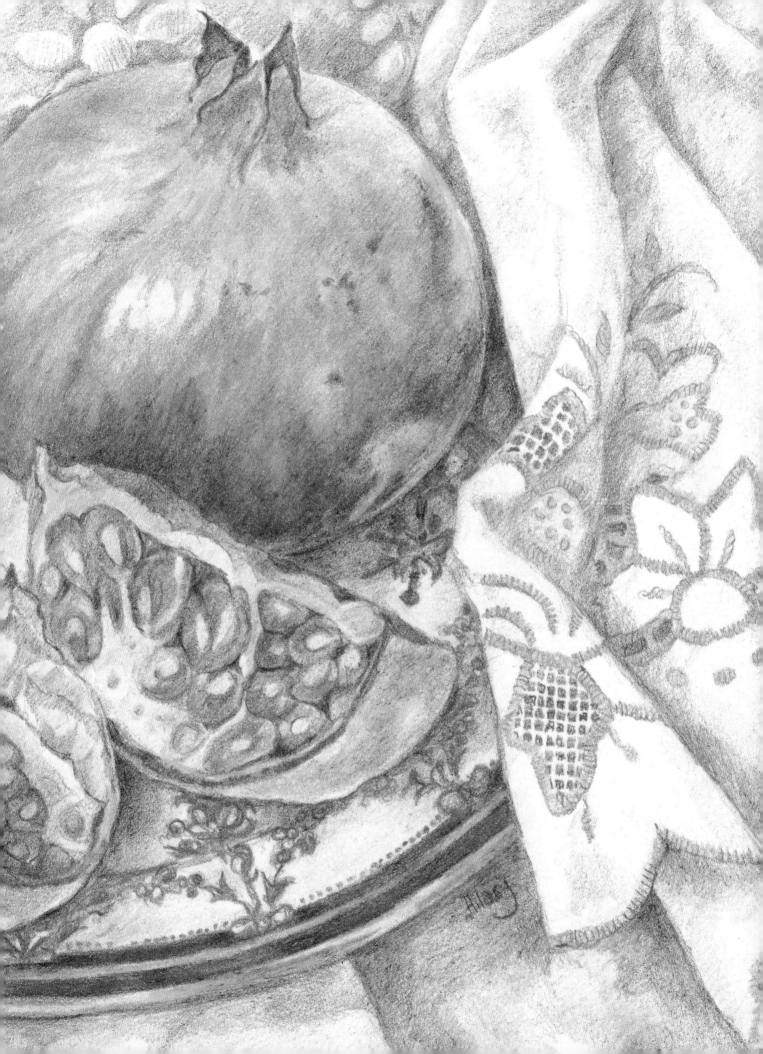

A QUINTET BOOK

Published by A&C Black Publishers
37 Soho Square
London W1D 3QZ
www.acblack.com

ISBN 0-7136-6924-1

This book was designed and produced by
Quintet Publishing Limited
6 Blundell Street
London
N7 9BH

Project Editor: Duncan Proudfoot
Editor: Anna Bennett
Designer: Ian Hunt
Photographer: John Melville
Creative Director: Richard Dewing
Publisher: Oliver Salzmann

Manufactured in Singapore by Universal Graphics Pte Ltd
Printed in China by Midas Printing International Limited

Contents

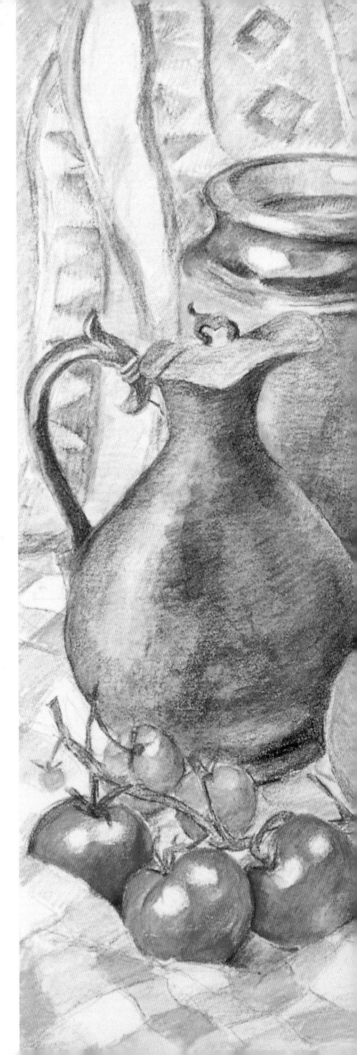

Introduction

WATERCOLOR PENCILS

Working with watercolor pencils is almost like working with paint in pencil form. The pencils combine the precision and control of pencil drawing with the flexibility of watercolor paint effects. All paints and pencils are made up of pigment and binder. The pigments are the same for all paints, but the binder may be oil, chalk, gum arabic, or some other material. In ordinary color pencils, the binders vary depending on the manufacturer, but with watercolor pencils, there is less variety because—whatever the binder is—it has to be water-soluble. For this reason, the various makes of pencils tend to differ in the type and quantity of pigment they contain and in the colors that the manufacturer has created. Colorfastness and permanence are still slight problems with watercolor pencils, but this is less an issue than with many watercolor paints. The pigment in the pencils is not quite as finely ground as with watercolor paints. This means that watercolor pencils do not have precisely the same quality of translucency, although the fatter granules of color on the page are more resistant to the fading effect of exposure to daylight.

DIFFERENT MAKES OF WATERCOLOR PENCILS

Sets of 6 or 12 watercolor pencils usually have fairly garish colors. Theoretically, one should be able to mix all the colors of the rainbow from the three primary colors, but in practice this is virtually impossible. Cheaper sets have a smaller range of colors, making subtle blends very

difficult. Buy the largest set you can afford because the more interesting and useful colors are included only in the bigger sets. There are wonderful sets of 72 colors, but you can also get a wide range of hues with a set of 48. Most watercolor pencils come in flat tins, which makes it easier to carry them and to find the colors that you want. Most artists tend to use certain ranges from each set and mix and match them all. It is a good idea to keep your pencils in a suitable box with your favorite colors at hand, so they are easily visible.

Take care not to drop your watercolor pencils. The lead in the pencils can break quite easily, and you could waste half a pencil in a frustrating attempt to sharpen the point of a broken lead. For the same reason, avoid lending your pencils to small children. Keep a cheap set separately for those budding artists.

Even when you have 72 watercolor pencils in a set, you will find that you need to mix colors to get the exact color you want. When you add water, the colors change slightly. Familiarizing yourself with your pencils is important, and an excellent way to do this is to create little swatches of each color as a reference. Divide each swatch into three small areas; press lightly in one, heavily in another, and wet the final area. It is possible to layer colors, as with colored pencils. Once you are used to both the differences between the colors and the way in which they change when wet, you will be able to produce realistic colors, using some wet and some dry pencil effects.

PAPERS

Watercolor pencils have hard points just as color pencils do, so you would expect to need a smooth, hard surface, such as Bristol board. However, painting with watercolor pencils involves water, and this requires a suitably resilient paper or board. Bristol board reacts badly to water because it is prepared with China clay, so it is better to use fairhty thick watercolor paper.

Watercolor papers come in three main types: "hot-pressed" (ironed flat), "cold-pressed," and "rough," which is usually too coarse for pencils. Big brushes would let watercolor paints drain into the dips and hollows of rough paper, but the hard points of pencils would make very rough and ragged lines.

Watercolor paper is also classed by the weight—either a square meter of paper in grams (grams per square meter) or, in Imperial measures, a ream of paper in pounds. A 190-gsm (90-lb) paper is thin, while a 640-gsm (300-lb) one is thick, but expensive. Choose paper of a fairly heavy weight—300 gsm (140 lb) or more—so that each sheet of paper is reasonably thick. Remember that once you add water, any sheet of paper will stretch, although thicker papers will withstand stretching better than thinner ones will.

You can buy pads of prestretched, hot-pressed paper, which are glued around the edges to prevent them from stretching further. If you want

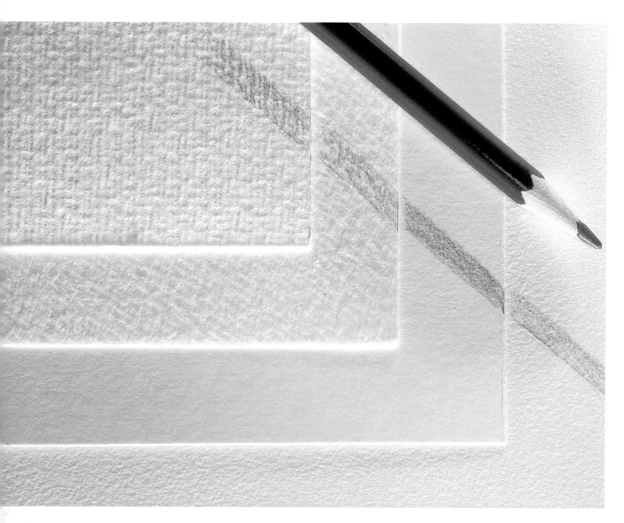

Left Unless you specifically want to make use of the rough textures of particular papers, look for "hot-pressed" papers. Basically, this is paper that has been ironed.

Right You will only find out what papers and other grounds suit you by experimenting with them—nobody can give you a definitive answer. You may find that you prefer working on colored papers, or even highly textured papers.

to buy loose sheets of paper, there are many different qualities of hot-pressed paper, but bear in mind that thicker papers are less likely to stretch when you add water. You can also buy heavy-duty construction paper, which works quite well with watercolor pencils because it doesn't stretch and buckle as much as the lighter weights do—it just bends slightly. But the choice is up to you. You will find that you prefer some surfaces to others, and this can be because of the "size" (coating) with which the paper has been treated, as well as the type of surface (hot-pressed, cold-pressed, or rough). Construction paper may have a lot of size, while some hot-pressed papers have very little. Paper with very little size will absorb your paint, but heavily sized papers allow the paint to stay on the surface.

Some artists prefer parchment papers because they give pictures a translucent quality. But some of the complications with parchment papers is that they need stretching; when you have taped them down with gum-strip paper and left them to dry, they will pull and tear the gum-strip. The way to solve this sort of problem is to use three layers of gum-strip paper. Some papers, such as heavy-duty cartridge, tend to leave the color floating on top, which can result in a blotchy surface. Others absorb the color, and once you have added water, you will find that you cannot move the colors round at all.

OTHER EQUIPMENT

Most watercolor artists use a slightly tilted board because an easel will allow water to run down the page. It is more convenient to work at a desk and have your pencils beside you. Sitting at a desk is less tiring than standing, but the disadvantage of working like this is that you see your painting at an angle. This makes you view the drawing at a distorted angle, which can cause you to draw the subject out of proportion. Because of the angle of the board, you may sometimes find that you begin a drawing too high on the page, which is something to watch out for. Empty space at the bottom can be corrected with the right framing, but cramped areas at the top are more difficult to deal with.

An electric pencil sharpener, whether battery- or mains-operated, is a very handy tool. The twisting action of handheld sharpeners can break the leads, and using a craft knife requires great skill. For extremely fine points on your pencils, keep a piece of fine sandpaper handy to use after the electric sharpener. An electric pencil sharpener is also useful because you can sharpen pencils with one hand while you hold your board or an assortment of pencils in the other.

BRUSHES

When using watercolor pencils, you tend not to wet huge areas at a time, so you won't need large brushes. Usually a medium brush will do for wetting larger areas, and a small one will work for detail. Artificial brushes keep their points for a reasonable time and are enjoyably springy, but when they wear out the ends become fuzzy and frayed. Discard them when this happens, or use them only for lifting and "scrubbing" the surface of the paper. Sable points last much longer, as long as you take proper care of them.

ERASERS

Colored pencils and watercolor pencils are not as easy to erase as graphite, but determined erasing will lift quite a lot of pigment, as long as the pencil has not been wet. The less expensive types of plastic erasers seem to tackle everything from graphite to pastel and are suitable for most purposes. Kneaded erasers do not seem to be any more effective, and paper cleaners often leave a grayish deposit. The effectiveness of an eraser will depend on how much pressure was applied when a line was drawn. An eraser will not easily lift pencil that has been ground into the paper, leaving a groove that the eraser cannot reach. Remember that if the paper has been wet, the pencil will have dissolved, bonding with the paper, and this will be very hard to lift without the use of water.

Electric erasers work well for very fine detail. Another method of lifting paper is to use sticky-backed plastic (transparent laminate used for covering books, maps, and so on), which is sold in most stationery stores. To lift dry pencil marks, peel back the protective layer on a small strip and lay it—sticky-side down—on the penciled area you want to remove. When you lift the plastic, the layer of pencil will come off with the plastic. However, if you use this method on the same bit of paper too often, you will damage the surface of the paper.

You will also need graphite pencils to make initial rough drawings. Graphite is much easier to erase than watercolor pencil is. A mechanical pencil with a thin lead, which does not have to be sharpened, is useful at this stage. Blotters,

such as paper towels, tissues, or cotton balls, are also very useful. A small water jar with a screw-top lid is always a good addition to a sketching kit.

Use black or white ink and a crow quill pen, or a felt-tip pen, together with watercolor pencils to create interesting effects. Masking fluid is very helpful in re-creating the appearance of waves and seaspray, and it can be applied with either an old toothbrush or a color shaper latex tip. Brown gum-strip paper is used when stretching paper, and masking tape will attach individual sheets of paper to a drawing board.

Below The only equipment that you really need for drawing and painting with watercolor pencils are the pencils themselves and a brush. However, there are additional techniques that you might like to try, which require a few extra pieces of equipment.

Suggested materials

1	Watercolor pencils	10	Crow quill pen
2	Masking fluid	11	Graphite mechanical pencil
3	Black ink	12	Felt-tip pen
4	White ink	13	Masking tape
5	Electric pencil sharpener	14	Plastic laminate
6	Eraser	15	Tissue
7	Brown gum-strip paper	16	Water
8	Color shaper latex tip	17	Paper towel
9	Medium Sable brush		

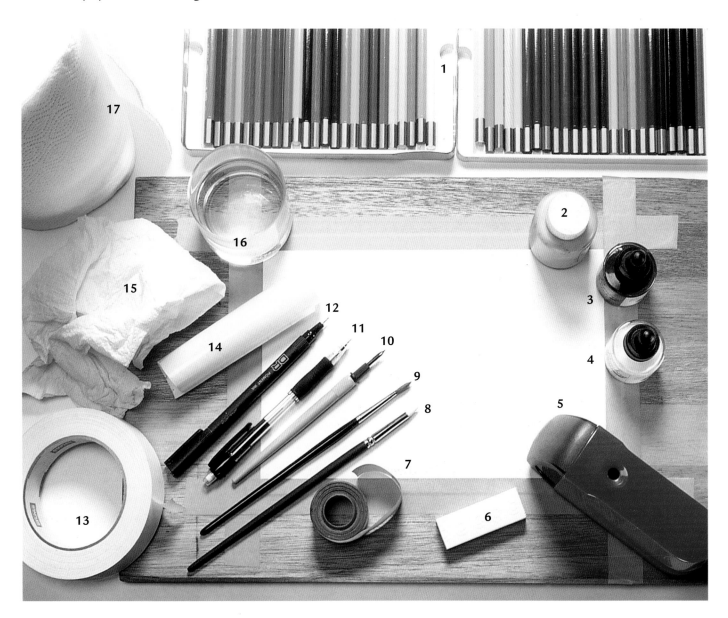

HOW TO STRETCH PAPER

You will need a flat wooden board that will absorb water. You can use plywood or wooden-surfaced drawing boards. Blockboard and ordinary plywood will work in the short term but will fall to pieces after a while. Do not use Formica or plastic-coated board; these do not absorb water, and your paper will remain waterlogged for too long. Some boards discharge yellow or brown liquid when wet, so if you are working with a board you have not used before, be sure to wipe it down thoroughly beforehand.

Sometimes you have to scrub and sponge a board for more than 20 minutes to get the residual color out of the surface. When you have stretched your paper, leave it on the board, and paint your picture while the paper is stuck to it. When you have finished, run a craft knife gently down the edge between the paper and the board (halfway across the gum-strip paper). Be careful not to carve into the wood. Gently lift your painting from the board and trim away the border of gum strip paper.

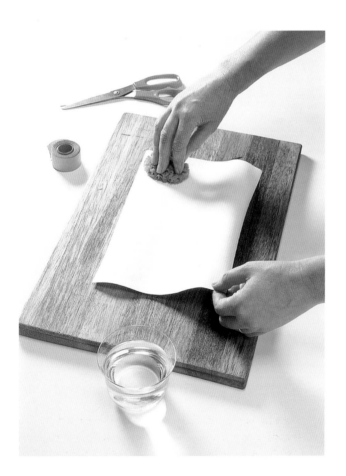 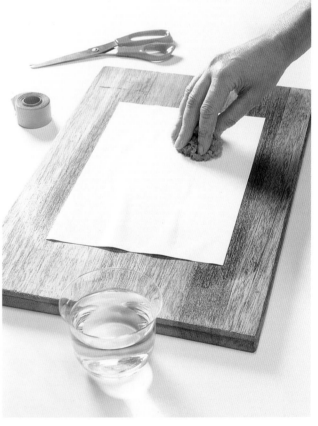

1 Cut your paper to size—smaller than your board, but slightly bigger than the area you want to paint. You will lose some of the edge when you trim off the gum-strip paper. Wet the paper thoroughly using a clean sponge.

2 You can immerse the paper in the bathtub or sink or wet it gently by using a bath sponge on the wooden board. If you wet it on the board, turn the paper over a few times so that you wet both sides. Be careful not to rub the paper too roughly with the sponge, as you may damage the surface.

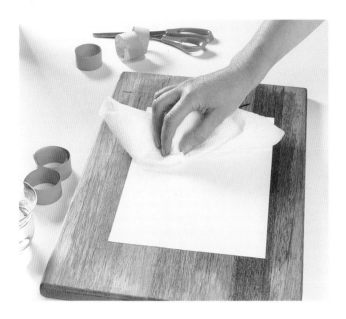

3 Gently smooth any air bubbles to the edges so that the paper is flat on the board. Eventually the bubbles will stop forming, and your paper will stay flat. It has now absorbed as much water as it can.

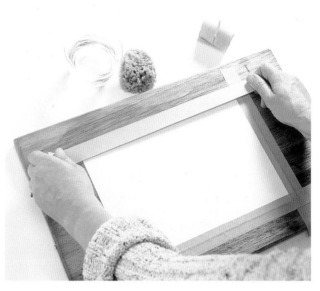

4 Stick the paper to the board with brown gum-strip paper. This contains water-soluble glue and will absorb the water and remain stuck to the wooden board underneath.

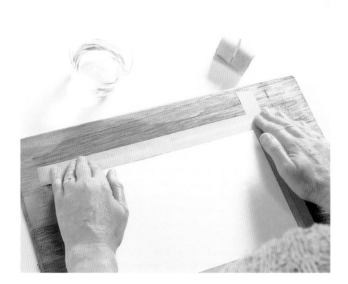

5 Stick the gum-strip paper half on the paper and half on the board, so that when the paper tries to pull in as it dries, there is equal pressure on the paper and the board.

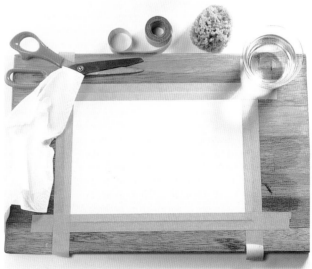

6 Leave the paper stuck on the board, and allow it to dry naturally. When the paper is dry, keep it attached to the board while you paint; once you cut the paper off the board, it will stretch in a different way when you add water to it.

Key terms

Broken colors—Small marks of different colors alongside one another that blend optically to create a new color.

Burnishing—Filling in any tiny holes through to the paper in a drawing to blend the underlying colors and leave a glossy surface.

Cold-pressed—A paper-making process that leaves a particular finish. Cold-pressed—also called NOT (from NOT hot-pressed)—papers have an open or coarse texture.

Complementary colors—Colors that lie opposite one another on the color wheel and have the effect of enhancing each other. For example, red is the complement of green, and orange of blue

Composition—The arrangement of the subject matter in a way that is harmonious and pleasing to the eye.

Cone cells—The cells in the eye that see color.

Contour shading—Shading across an object following its contours, rather than along its length.

Contrast—The difference in value between light and dark.

Cool colors—Colors that contain blue and green, suggest coolness, and are associated with water, sky, and foliage

Crop—To trim a picture's edges.

Crosshatching—A technique for shading that uses sets of short parallel lines at right angles to each other.

Discrete—Separate, distinct; as in working on "discrete" areas of a painting.

Dynamism—Vigor; a dynamic composition is one that directs the viewer's eye to move around the picture.

Dissociate—To remove yourself; to dissociate yourself from your painting is to get some critical distance from it in order to assess it.

Eye line—The line that would be created if you gaze straight ahead, without tilting your head up or down.

Focal point—The main point to which a viewer's attention is attracted in a picture.

Foreground—The area of a picture, often at the bottom of a painting, that appears to be closest to the viewer.

Foreshortening—A perspective term applied when one is representing an object oblique to one's line of vision.

Form—The 3-dimensionsal appearance of the subject matter—its line, contour.

Gradation—A gradual, smooth change from dark to light or from one color to another.

Gum-strip paper—Tape with water-soluble glue that sticks to both the paper and the wooden board when stretching paper.

Highlight—The area on any surface that reflects the most light.

Horizon line—A level line where water or land meets the sky. Vanishing points are usually located on this line.

Hue—Any color as found in its pure state in the spectrum.

Intermediate or tertiary colors—Colors produced by mixing unequal amounts of two primary colors. For example, adding more blue to green (the combination of blue and yellow) will produce the intermediate color of blue-green.

Linear perspective—A technique of drawing or painting used to create a sense of depth and

three dimensions. Most simply, the lines of buildings and other objects in a picture are slanted inward making them appear to extend back into space.

Masking fluid—A removable latex gum resist used to protect or reserve selected unpainted areas from wet paint.

Medium—The material or technique used by an artist to produce a work of art.

Negative space—The space around an object, which can be used as an entity in composition.

One-point perspective—A form of linear perspective in which all lines appear to meet at a single point on the horizon.

Opaque—Something that cannot be seen through; the opposite of transparent.

Ox gall—A traditional watercolor solvent, which "melts" watercolor pencil lines more thoroughly than water, giving a smoother blend.

Palette—A selection of colors used in a painting. Can also be used to describe a board or container for mixing paints.

Perspective—The graphical representation of distance or three dimension.

Pigment—The color in any paint or pencil, held together with a binder; it is water-soluble in watercolor pencils.

Plastic laminate—Clear film with adhesive on one side.

Primary colors—The colors yellow, red (magenta), and blue (cyan) from which it is possible to mix all other colors of the spectrum.

Proportion—A principle of design referring to the relationship of elements to the whole and to each other.

Rod cells—The cells in the eye that see light and dark, or tonal values.

Rubbing—Using a finger to smudge pencil marks to create a more even finish.

Rule of thirds—The four possible focal points produced by the intersections of lines dividing a page into thirds, both horizontally and vertically.

Sable—A tense but flexible hair with excellent paint and water holding ability, used for brush bristles.

Secondary colors—Colors obtained by mixing equal parts of two primary colors. These are orange (red and yellow), green (blue and yellow), and purple (red and blue). Also refers to all mixed colors.

Shading—The means by which a three-dimensional appearance is given to a two-dimensional drawing; the application of light and dark tones.

Size—A smooth coating on the surface of some papers that makes them smoother and less absorbent.

Sketch—A quick freehand drawing or painting.

Splattering—A method of spraying droplets of paint over a painting with either an old toothbrush or a flat brush.

Texture—The surface quality or "feel" of an object, its softness, smoothness, or roughness.

Tone—The variation in light and dark of a subject.

Translucent—Transmitting light but causing sufficient diffusion to prevent perception of distinct images.

Vanishing point—The point on the imaginary horizontal line representing eye level where extended lines from linear perspective meet.

1
Mastering basic techniques

There are many ways to make marks with watercolor pencils, from bold strokes that create vibrant textures to gentle marks that give good coverage and create an even coating of color. At different stages of a drawing, you will use different techniques, but largely the choice is up to you. Choose whichever method you feel most comfortable with; this chapter offers many options.

Many people struggle to draw confident outlines. There is a way around this, similar to backstitch in embroidery, where long lines are built up slowly by moving backward and forward on the same line in tiny segments. This chapter also offers advice in the use of guidelines in drawing symmetrical, cylindrical objects.

Watercolor pencils offer the best of all worlds—the wash effects of watercolor in the form of pencil marks "melted" by the addition of water, and the control and fine detail of pencil points. One of the initial stages of a watercolor pencil painting is to lay down overall ground color before wetting the whole picture for the first time to allow the color to sink in to the paper. This provides a good base on which to start your pencil work.

Fundamental techniques covered in this chapter include how to capture the tiny inconsistencies that make up natural form and how to shade successfully to create three-dimensional effects. The key is to identify not only primary highlights from the main light source in the picture, but also the secondary highlights—light reflected by other objects. The basis to any successful picture is to grasp the tonal quality of what you are looking at; the basic areas of light and shadow in a composition.

Wetting and "melting" colors is a major advantage in using watercolor pencils. This chapter looks at when and how to add water and which brush to use. Occasionally, even the best artist can slip up and draw a line in the wrong place, stroke slightly too heavily, or color over a highlight that should have stayed white. There are excellent techniques with watercolor pencils to correct mistakes at different stages of a drawing. These are tremendously useful and very easily mastered.

The demonstration of a still life on pages 30–33 shows you how to get started with a limited palette, looking primarily at the tonal balance in a composition—the balance of light and shadow. There are no hard and fast rules when it comes to drawing and painting. Be creative and don't be afraid of trying something new. It is only by experimenting and following your instincts that you will learn what works for you and what doesn't.

What are some techniques for creating different effects in watercolor pencil?

There are many different ways to make marks with watercolor pencils. If you are going to wet your lines, the color will mostly dissolve and the lines become less prominent, or even disappear. For lines that you want to appear in your finished picture, however, you need to think carefully about texture. The important thing is to work lightly, and build your picture slowly—don't leave grooves in the paper.

A relaxed, meandering unbroken line is probably more useful as a way of making marks before you wet your picture than as a technique for final shading. It provides good coverage, but it lacks the necessary control for more detailed work.

Short, separate lines, roughly parallel to each other, give a vibrant texture. This technique is better suited to use after you have wet your picture. The technique of broken colors employs lines of different colors—adjacent to one another but not overlapping—to "trick" the brain into seeing a composite color.

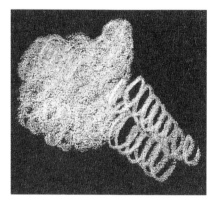

Use slightly longer lines, parallel to each other and overlapping, to create texture as well as to cover large areas before wetting. This is a common shading technique.

A light spiralling line made over the same area until well covered, is also a useful shading technique, allowing good coverage before wetting. It is also very good for blocking in larger areas of color when starting a picture.

An unbroken zig-zag line can be used to create a more dynamic area of shading.

What is the best method of drawing cylinders and ellipses?

Many people struggle to draw outlines with confidence because they seem so absolute. Before you begin, put your pencil on the paper, and pull a line toward you. If you do this in one stroke, you may feel that you have very little control and that the line wanders about a bit. To overcome this lack of control, try the technique described below.

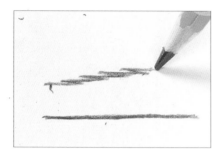

Draw ½-inch (1 cm) toward you. Then retrace ¾-inch (½-cm) backward, before dragging the line about ½-inch (1 cm) forward. You are effectively drawing the same part of the line twice. Turn the paper so that the line is always coming toward you to give greater control. In the picture, the jagged line is overemphasized to give a clear idea of how the line is being drawn. In reality, your line will look much more like the one in the foreground.

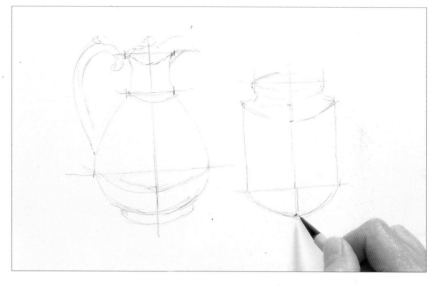

Begin by drawing the central, vertical, and horizontal guidelines of symmetrical, cylindrical objects, such as vases or pitchers. Measure across from your central guideline along the horizontal guidelines to mark the width of the cylinder at various heights. These marks should be the same distance from the vertical guideline on either side.

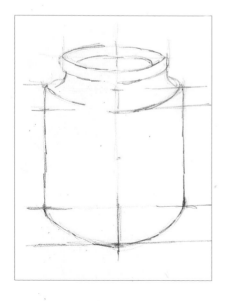

Left The ellipse at the base of a cylindrical object is "deeper" than the ellipse at its top. This is because you are looking at it from higher up and so see more of the circle. If you looked straight down into a cylinder, you would see a complete circle.

Right The top of a cylindrical object at exactly eye level will appear as a straight line, rather than as a circle or an ellipse. If you see the top of a cylindrical object looking from below, it will appear as an ellipse again.

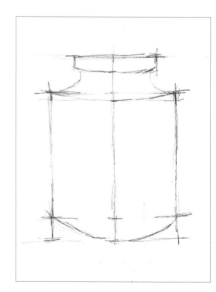

How do I put on overall ground color?

When applying overall ground color, it is more important to cover the area than to make detailed marks. This is because overall ground color will be wet, which will obscure the marks to an extent. There are two techniques that are very good for this: one is to use small, overlapping spirals; the other is to use short, parallel, overlapping lines. Press lightly on the paper to avoid digging into the surface.

Make tiny overlapping spirals with your pencil, working gradually to cover the area. The spirals build to an area of relatively flat color.

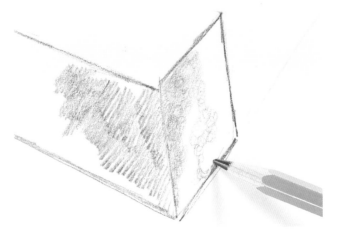

Here you can see both styles of applying overall ground color. In blue you can see the overlapping, straight lines; in green you can see the small spirals.

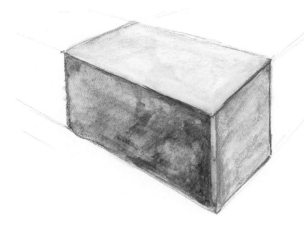

When you add water for the first time, your drawing should not be very detailed. The water dissolves the pencil marks and fills in all the minute holes, so instead of seeing pigment against a series of white holes (the paper), you are seeing an even spread on which you can work again with dry pencils.

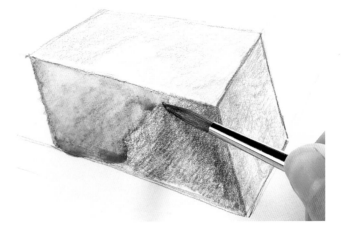

Adding water "melts" the pencil marks, creating a wash on which further pencil marks can be made. Here, two colors are combined, and most of the pencil lines are dissolved to give a flat wash.

How do I capture natural forms?

Nature's secret is that there is infinite variety of shape and color. Never assume that a piece of fruit or a flower head will be regular or identical to another.

INDIVIDUAL OBJECTS

With this example of a tomato, the first challenge is to draw the shape accurately. Objects that you might think of as spherical, such as oranges, apples, and tomatoes, are never completely round. A fractional deviation from a perfect circle can make all the difference. Here, you can see that the outline of the tomato deviates from the perfect circle within which it has been drawn.

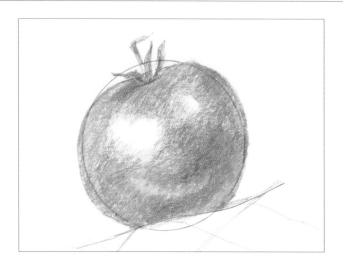

GROUPED OBJECTS

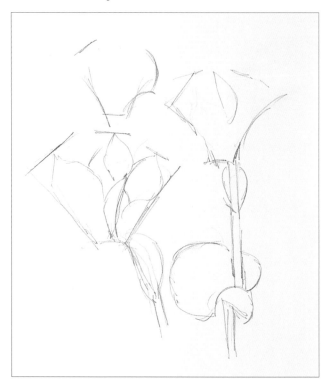

1 Get the rough shape and angles of the whole flower when drawing large-petalled flowers. Then find and define the top of each petal, adding guidelines for definition. This will show you where the petals deviate from the regular shape of the flower so you can see a natural object rather than a regimented form.

2 It is is the minor deviations which will give your drawing a sense of rhythm and reality, as natural objects are never completely symmetrical or regular. This applies not only to small objects, such as flower petals, but to larger subjects, such as trees, woods, and even clouds.

How do I arrange objects to make a dynamic composition?

It may seem strange to discuss dynamism with reference to still life, but this refers to where the eye is drawn within the composition. To increase dynamism, place the objects at different heights and at different distances from the viewer. Arrange the objects so that they overlap and relate to each other in some way. Our brains like patterns, and when objects overlap or are connected to each other, a viewer is better able to enjoy a picture. Unrelated objects make uncomfortable viewing because they do not create patterns. As well as making a more interesting composition, having the objects touch and overlap makes them easier to draw. Position objects so that they face inward rather than outward—for example, a pitcher will usually have its spout facing inward, because this will lead the eye back into the picture.

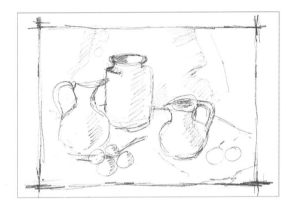

In this composition, the objects are too dispersed. There is no relationship among them, making the effect of a number of separate pictures, which is neither dynamic nor aesthetically pleasing.

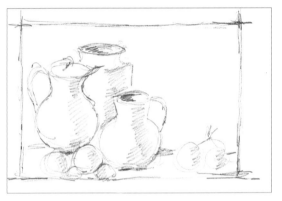

In this composition, the way that the objects are arranged makes it look too cramped and too weighted to the left-hand side of the frame. This leaves the right-hand side empty and visually dull.

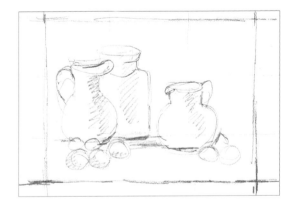

Here, there is too little variation in the height of the objects. If everything is the same height and on the same level, the composition will be uniform and without dynamism. The eye is drawn horizontally across the piece along rows of interest.

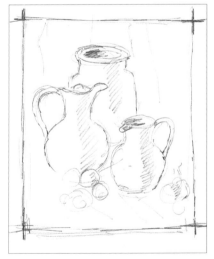

This is the best composition of the four. The variation in height of the objects, with each placed on a different level, draws the eyes through the painting. The objects are at different distances from the artist and they overlap, which makes a balanced composition. The pitcher points inward and slightly toward the artist and engages more with the viewer.

Where should I place the focal point of my picture?

The focal point of your picture should be the most interesting part of your composition. Sometimes it works to have this right in the center, but generally it is a better idea to place it slightly off center from lines drawn horizontally and vertically across the center of the page, as this encourages the viewer's eye to move rather than remain static.

This first sketch shows the focal point right in the middle of the drawing. The viewer's eye is held there, almost trapped by the focal point.

This second sketch shows a focal point downward and to the left, with the movement of the arrangement drawing the eye upward and away toward the top, right-hand corner of the picture. This is a very dynamic image.

The third sketch shows a variation on the second arrangement, with some of the movement heading leftward and downward from the focal point. This creates a more balanced, calmer image.

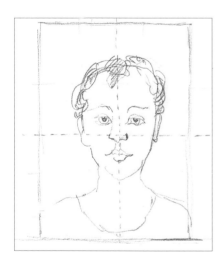

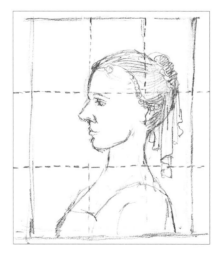

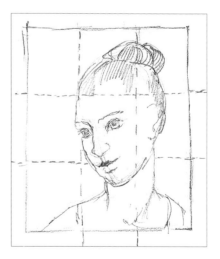

You may be tempted to have your model's nose right in the middle of your picture, but this may result in a lifeless, staring portrait. Experiment with other options to arrive at a more dynamic composition.

A profile sometimes works surprisingly well. It gives a sense of watching without being seen, and the eye can be caught by the line of the neck or hair.

A three-quarter view encourages the viewer's eyes to move around the picture, as here with the sweep of the jawline and shape of the hair reaching to the upper right corner.

How do I shade a drawing to create a three-dimensional effect?

Three dimensions are defined by the play of light on an object. First, consider what direction the light is coming from. Bear in mind that there may be numerous light sources of different intensities. Some light will be reflected between objects, casting secondary highlights and creating unexpected colors.

Try out different styles of shading and choose one that suits you. Arrange lines in groups close enough together to look like an area, rather than individual lines. Or place groups of lines together, altering the angle of each group a little to build up texture—do this with a single color or a few different colors. Use varieties of crosshatching or contour shading, which follows the line of the object you are drawing. Contour shading is generally intended to show in the finished artwork—lines can be straight or curved, depending on the subject and your preference.

PRIMARY HIGHLIGHTS

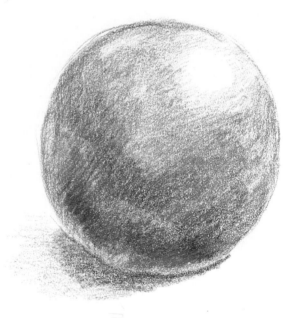

1 Select the lightest part of the object and start shading around it, leaving the brightest parts white or as light as they appear. The brightness of your highlights will depend on the contrast between this lightness and the surrounding drawing. Notice how much light or shadow is cast by surrounding objects. The very edge of an object on its shadowed side is seldom its darkest point—there is often some reflected light from the surface below or from some adjacent object.

2 Use slightly darker toning colors (colors in the same family) to shade. You can also achieve darker colors by pressing slightly harder. In this example, the shadows on the red ball have been created using a deep, purplish red, and crimson. Shadows cast by an object itself are also important in creating a complete three-dimensional effect.

SECONDARY HIGHLIGHTS

1 In this sketch, the white pencil shows the main highlights on the metal vase and the apple. When drawing on white paper, identify these to start with, and leave them blank or very light.

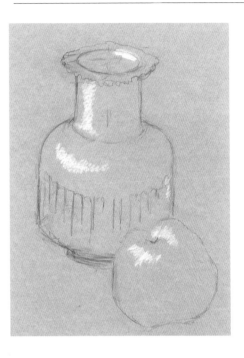

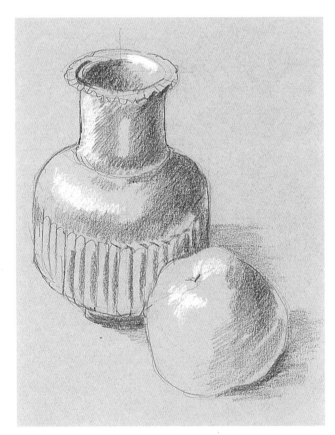

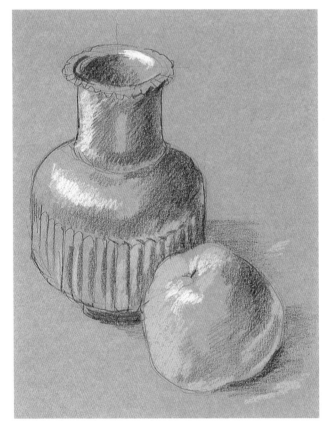

2 Add the shadowed areas next. To define the darkest values, half-close your eyes and squint at what you are drawing. This cuts out some of the cone cells in your eye, which see color, allowing the rod cells to see the tonal value. You can then discern which are the darkest areas, rather than drawing them where you think they should be.

3 Once you have drawn the darkest areas, it is easy to distinguish the secondary cast highlights, caused by reflections from adjacent objects. Here they can be seen, drawn in orange pencil, such as on the bottom edge of the pot and above the deeply shadowed areas.

What are some tips for applying water?

The initial wash, after penciling in the basic ground color, involves wetting fairly large areas. For finer detail, which involves wetting tiny areas, you will need much more control over the amount of water you apply and the areas to which you apply it. For both purposes you can use a medium sable brush—it gives you softness with spring, and it is hard-wearing. If you prefer to work with a large brush, make sure that it keeps its point well. A variety of effects are possible, depending on how much water you work with.

For example, if you apply a wet brush firmly to pencil marks on paper, it will lift and blend the marks into a color wash. If you want to achieve subtle emphasis, dip only the point of the brush in water, and then apply to the paper. If you dip your pencil in water, it produces a very intense line, but one that takes a long time to dry and is almost impossible to change or erase.

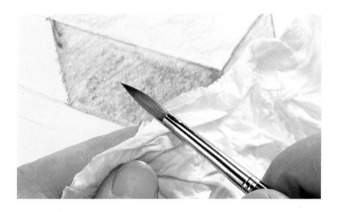

Limit the quantity of water in the brush by touching the back of the brush with a tissue to soak up any excess water. This will help you control the amount of water you put on the page.

Mix colors on the page by wetting the pencil marks and drawing them together, although not dissolving the marks completely. The aim with an initial wash is to "melt" the colors and produce a base on which to do further penciling.

If you drag your brush away from a colored area, it will produce hard-edged areas of color.

Another way to wet your picture is to use clear water and a clean brush to draw water onto penciled color. This wash method avoids hard lines and gives a more gentle dissipation of color.

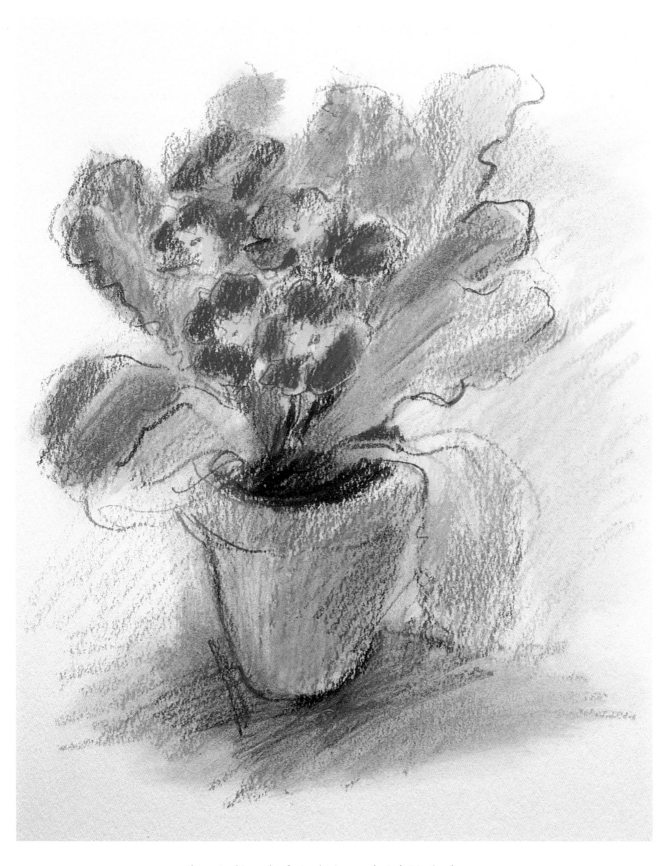

Above In this study of primulas in a pot by Judy Martin, the brushed color comes up very fresh and intense, contrasting nicely with the more open surface qualities of the pencil shading and line work.

What if I make a mistake. Can I make corrections in watercolor pencils?

If you have not yet wet your drawing you can use either an eraser or sticky-backed plastic. Plastic laminate will lift pencil marks and restore the clean surface of the paper, but an eraser will only lighten the pencil. If you have already wet your picture, you can use a clean, wet brush and a tissue, but this will only work well on paper that is not too absorbent.

ERASER

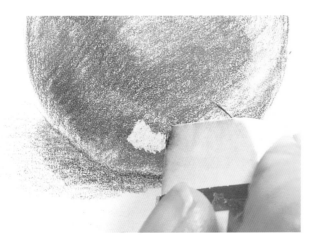

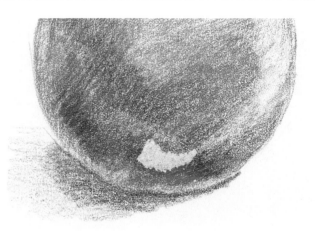

1 Use an eraser to make corrections to dry pencil work. This will remove much of the color, but it will not restore the paper to a clean surface. Take care not to damage the surface of the paper by rubbing too vigorously.

2 You can see the slight highlight raised on the right side of the ball by the eraser. Compare this with the small area below, where plastic laminate has been used to lift a small area of pencil completely.

STICKY-BACKED PLASTIC

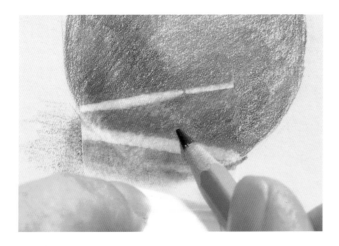

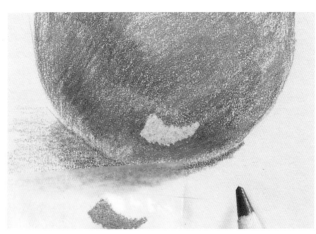

1 Take a small piece of plastic laminate and peel back the backing. Lay the sticky side down on the area of pencil that you want to lift. Use a pencil to rub gently on the plastic where you want to lift color.

2 When you peel back the plastic, the pencil will come away, leaving the clean surface of the paper behind. Do not use this technique too often on the same area, as you may damage the surface of the paper.

WET BRUSH AND TISSUE

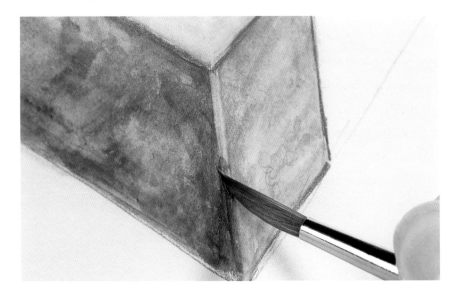

1 It is still possible to make corrections once you have wet your picture. On papers with plenty of size on the surface, you can wet an area and use a tissue to lift color. This will not restore the white surface of the paper, but it will make an appreciable difference. Here the top half of the line has already been lifted. First, use a clean, wet brush to wet the area that you want to lift. Use an old brush because you can damage the brush point by using it to lift color.

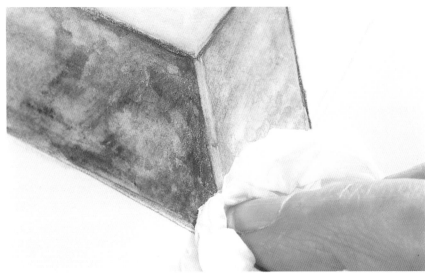

2 Gently dab the area that you have wet with a tissue to lift the color.

ARTIST'S NOTE

Kneaded erasers and art work cleaners often seem less effective than a standard eraser, because they can leave grimy deposits. If an eraser becomes grimy, you can clean it by vigorously rubbing it on a plastic or vinyl surface.

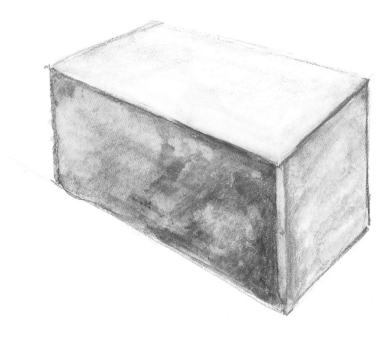

3 You can see how the color has now been lifted from the bottom half of the line. Wait until the paper is completely dry before using pencils on top of the same area. Otherwise, you could tear the paper, or produce either a wet line that is too heavy or a "skated" line that does not have enough depth or detail.

What if I make a mistake. Can I make corrections in watercolor pencils?

Demonstration: **Still life with assorted objects**

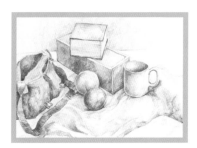

The aim of this exercise is to explore the different basic forms: spheres, a cylinder, cubic and rectangular boxes, and the more amorphous shapes of a cloth and a bag. Working with a limited palette, the main aim is to explore the basic tonal qualities of the arrangement without being too distracted by detail. Notice how the objects relate to each other, both in terms of form and in the light that they reflect onto each other and the shadows that they cast. Pay attention, too, to the effects of different textures.

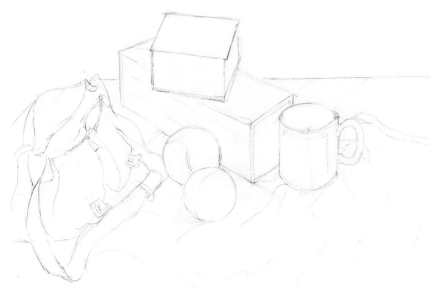

1 Draw an initial sketch, laying down some guidelines and picking particular edges of the objects in your still life arrangement. Concentrate on marking the key angles of different elements. Look particularly at the relationships between objects as well as their shapes. Don't worry about putting in too many lines, as these can always be rubbed out later.

2 Don't press too hard with the pencils—it is difficult to lift pencil out of grooves with an eraser, and indentations can cause problems when you get to the stage of adding water.

3 There are two ways of putting on base color. You can shade using short, parallel, diagonal lines or little circles, or spirals. Your marks should be light and on the surface of the paper. If you scratch the paper, this will show up, particularly when you add water. Don't rush these initial stages as you block in the basic areas of light and dark.

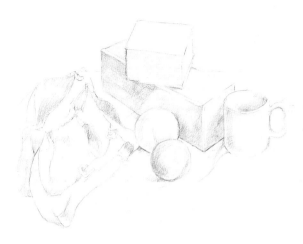

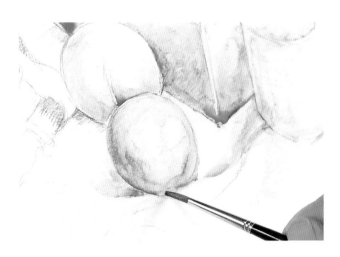

4 Before you add water, erase any areas of the drawing you are not happy with. For the light shadows, use paler blues, and for the darker shadows, use darker purples. If using grays, don't allow them to become too strident. Keep the toning very light before the first wash.

5 Using a fine brush with a good point, begin to add water to the drawing. Start gradually, adding small amounts of water to small areas of color. Concentrate on the color balance of the overall piece, and be careful not to spread color onto the highlights. .

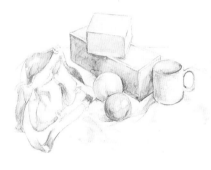

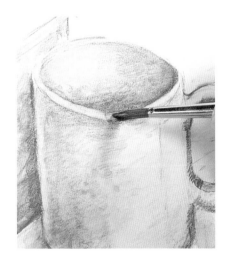

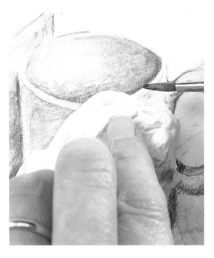

6 Allow the picture to dry completely before drawing on top of the wash. Being able to work on top of a wash with pencils is one of the advantages of watercolor pencils. Any harsh, unwanted lines left by the wash can be gently penciled over and you can correct any imbalances in the tonal balance of the picture.

7 If you are unhappy with any lines— particularly prominent ones such as the rim of the mug—make corrections with a clean, wet brush and a tissue. First wet the area of color that you would like to lift.

8 Then dab the wetted line with the tissue. While this will not restore the clean surface of the paper, you will be able to redraw the line where you would like it to go.

9 Now add warmer yellows and creams on top of the wash, on both shaded and nonshaded parts. This layer may dull the colors, but it will unify the painting. Use indigo—halfway between the reddish blues and the Prussian blues—for the shadows. Add burnt sienna and Venetian red to make the shadows warmer and to give them depth.

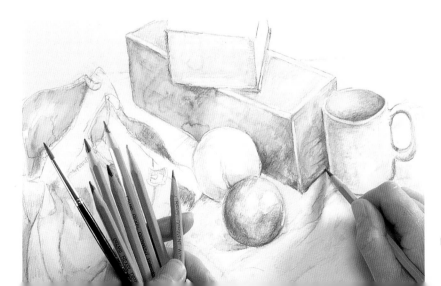

Demonstration: Still life with assorted objects 31

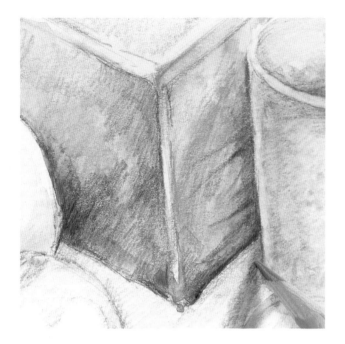

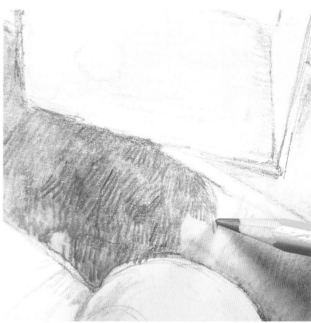

10 Draw hard edges clearly, such as the side of the mug, to define the mug's shape and its relationship to other objects. A clean strong line places the mug clearly in front of the box. Objects reflect light onto each other as well as casting shadows—look for the light in shadows, and you may be surprised by how much you see. Always think of objects in relationship to each other, not just as objects on their own.

11 If you are not planning to wet your picture again, take care that your lines don't show—unless you want to add texture. Use a form of crosshatching—series of short lines at an angle to each other—to create a solid, textured effect. Use two or three colors in the same area to create a blended color.

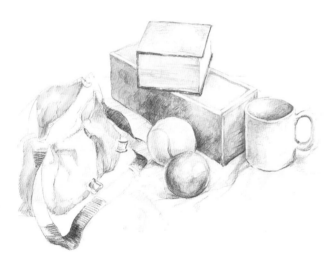

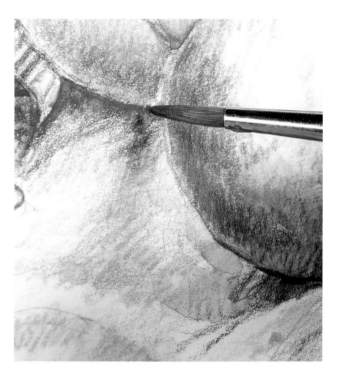

12 At this stage, the picture is nearly complete. Dark lines don't show up well against a dark background, so use really dark colors to create contrast. You can also use a pastel technique of using lines of different colors alongside each other to create a composite color, blended optically by the viewer.

13 In the darkest areas—for example, the shadow under the tennis ball—add a touch of water with the tip of a wet brush to enhance the contrast and to give the area of shadow the necessary strength. Use a brush to apply these final details.

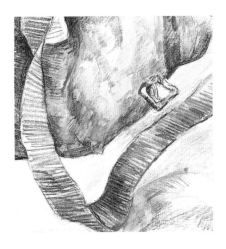

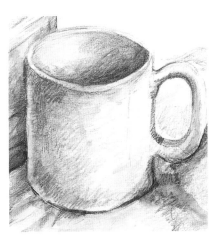

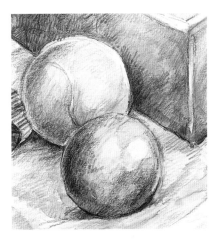

14 This detail of the strap of the bag shows a particularly bold pencil technique of strong parallel lines across the width of the object. The strap adds interest to the picture by running in several directions, twisting back on itself and drawing the eye toward the bottom-left corner of the composition.

15 The mug casts a shadow on the box alongside it, but it has light reflected onto its left-hand side and its bottom. Use different marks and work together different colors—even with this limited palette—to describe the transition from the highlight inside the mug to the shadow deeper in.

16 The smooth, reflective black sphere in the foreground shows clearly two highlights reflecting two light sources. The shadow on the sphere does not run quite to the edge as one might expect because of light reflected off the cloth. The shadow under the sphere is one of the darkest areas of the whole picture. The tennis ball, with a much less reflective surface, has softer highlights than the black sphere.

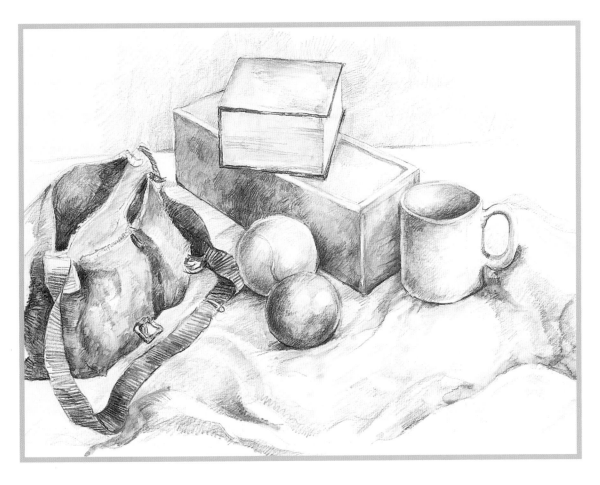

17 The aim of this still life exercise was to explore the relationships between objects in a composition, and to gain insight into the roles played by form, light and shadow, and texture in bringing harmony, balance, and authenticity to a picture.

Are there other techniques and media that I can use with watercolor pencil?

There are many techniques and additional media that you can use with watercolor pencils, from solvents other than water to watercolor washes, crow quill pens, and felt-tip markers. All these media and techniques expand the expressive range of the pencils.

WHITE INK

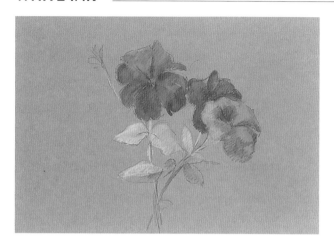

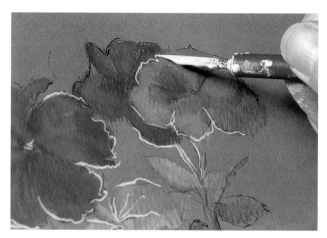

1 When using a crow quill pen and ink, make the initial drawing subservient to the ink outline. Define the flower loosely, more as areas of color than as a completed drawing—the ink must be the most powerful element in the drawing. Once you have laid down some color, wet it to create a wash on which to work with the crow quill pen.

2 Work with the crow quill pen and white ink on top of the drawing, tracing outlines and details such as veins on the leaves. The effect is more decorative than realistic. If you are working on colored paper, use colors that are either lighter or darker than the paper on which you are working, otherwise your colors may simply disappear.

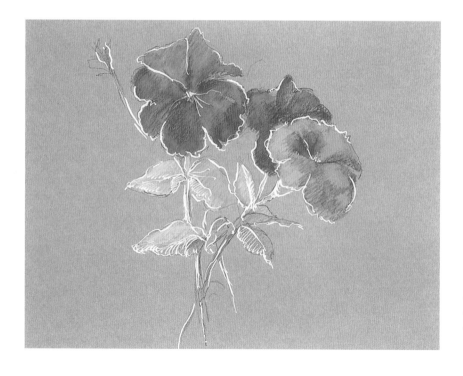

3 White ink works particularly well on colored paper. Here it helps to differentiate the flowers from the color of the paper. The ink picks out the form of the flowers, contrasting effectively with the loose, wash effect of the watercolor pencils.

OX GALL

When you use water to "melt" watercolor pencil marks and create a wash effect or merge different colors, some evidence of the marks underlying the wash remains. This is not a problem, but if you want to create a more even wash where the pencil marks are completely obliterated and colors more effectively combined, use ox gall instead of water.

Ox gall is a traditional wetting agent, which is used to make washes flow more freely or to create textures within wet washes. If you use ox gall with watercolor pencils, as above, the effect is usually much smoother. Generally, most watercolor pencil artists are perfectly happy to use water.

WATERCOLOR WASH

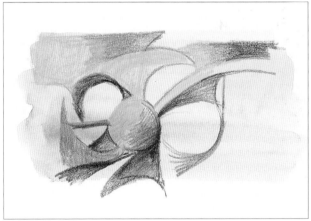

1 Another way to create a wash that is faster and more even than is possible with watercolor pencils is to use watercolor paints as a base coat. Lay down watercolor paint as a base for a drawing. This technique gives you the best of both worlds: the free-flowing expansive feel of watercolor washes with the precise control of watercolor pencils.

2 Use dry pencils to draw on top of the wash. This technique is a very successful marriage of two related media. Use the wash as the basis for any kind of drawing—here the drawing is abstract, drawn with colors that tone with the wash beneath.

1 Keep the background drawing very gently defined with no
 particularly strong lines. The initial drawing must allow the
final outline to predominate.

2 Draw freely with the pen and introduce some liveliness into
 the picture. This technique combines very effectively the soft
color of a watercolor pencil wash with the clarity and strength of
a brown felt-tip pen.

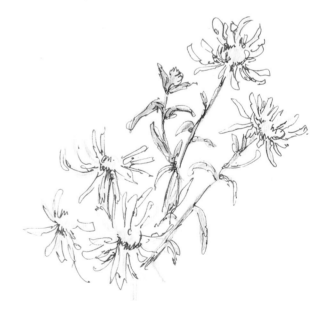

1 Draw the Michaelmas daisies loosely, simply describing
 blocks of colors. The outline will draw the picture together.

2 Use the felt-tip pen to bring some liveliness to the drawing.
 Use the bold quality of ink to enhance the colors underneath
and bring them into harmony, rather than overpower them with
the relative strength of the ink.

VAN GOGH-STYLE TECHNIQUE

1 Make the initial short, bold pencil marks vigorously. Lay colors alongside and at angles to each other to give the picture a sense of energy.

2 Apply a wet brush absolutely flat to the marks, dabbing rather than brushing. Color the white paper beneath, but don't allow the colors to merge into an indistinguishable mass. Clean the brush each time before applying it to the paper. The water enhances the color, giving the picture more impact.

3 Immediately work again with a wet pencil, adding texture and further color to the base below. Use this technique to create many different styles of pictures from abstract to realistic.

Are there other techniques and media that I can use with watercolor pencil?

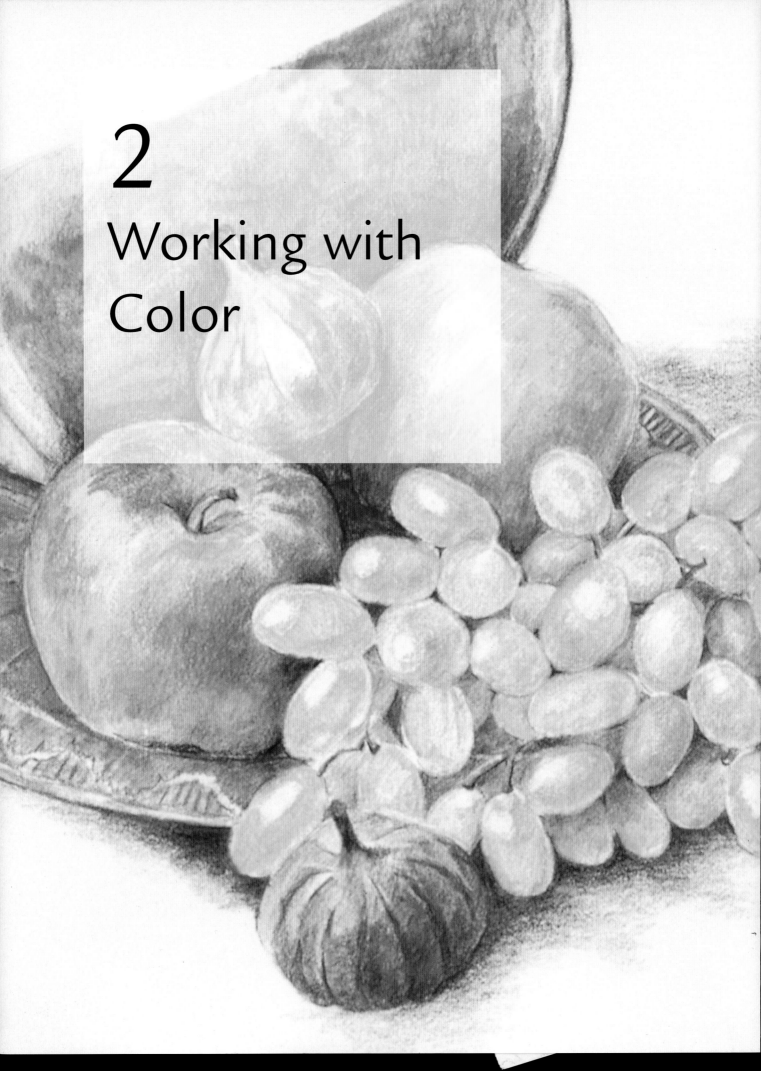

2
Working with Color

A good set of watercolor pencils presents an artist with a daunting array of colors. This chapter provides clear guidance on how to use those colors, looking at the color wheel and complementary and toning colors—what these terms mean and how to use color to achieve both strong contrasts to bring life to a picture and how to use toning colors to maintain clear, bright color. The color names on watercolor pencils will vary depending on the manufacturer; they will also differ from those in watercolor paint sets, even though they may share the same color name. Do not be afraid to experiment with your colors. Draw little color swatches in your sketchbook to see what they look like on paper.

Unlike watercolor painting where colors are mixed in a palette, with watercolor pencils, one mixes color on the page by layering different colored pencils. In nature, there is no such thing as an area of completely flat, uniform color. Use your watercolor pencils to layer many different colors to create realistic, composite colors. In this chapter, a step-by-step guide takes you through this process showing you how to achieve remarkably lifelike effects.

Drawing white objects is an excellent exercise in drawing what one sees, rather than what one thinks one sees. This is perhaps the most critical lesson in drawing and painting. We all have ideas in our heads about what we think things should look like, but if we look closely, what we see is sometimes very different from what we imagine. Light and shade will greatly affect the color of an object. By observing closely and drawing only what we see, we can do justice to even the most demanding drawing challenges.

Watercolor pencils give an artist a wonderful variety of colors to use. Enjoyment and success in working with color lie in learning to observe closely and to layer the many different colors that one sees, and in slowly building to a suitably complex finished artwork.

Can I keep my mixes from getting muddy?

The wonderful thing about watercolor pencils is the range of color you can achieve with a simple pencil. The degree to which you add color and water will both affect color. Dull colors are usually caused by having too many colors in a mix or by adding a color that is, by its nature, muddy. Colors closest to each other on the color wheel will mix bright colors that are clean and sharp.

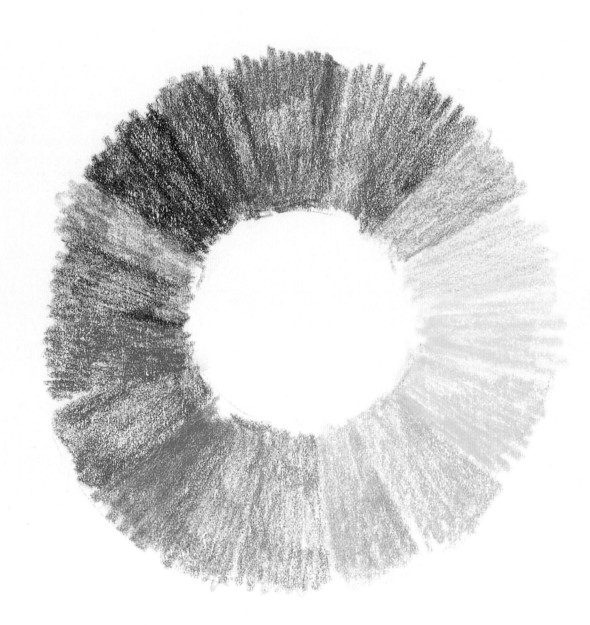

Color wheel
A color wheel shows the primary colors—red, blue, and yellow— in relation to one another. "Pure" colors on opposite sides of the color wheel are complementary colors, opposites that make each other stand out. Colors that are close to each other on the color wheel are toning colors, similar colors that work together for a gradual, more gentle effect.

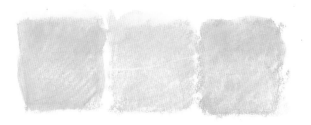

1 Mix colors close to each other on the color wheel, such as orange and yellow, to produce wonderfully clear, clean colors.

2 Mix two colors together that are not closely related on the color wheel, for example, scarlet and greenish blue, to produce neutral, more earthy colors.

3 Clean colors do not necessarily mean bright colors. Mix crimson lake and ultramarine to create a rich purple.

4 Certain colors are naturally muddy, for example olive green and bronze. Add these to any color and the result will be muddy. This does not mean that these colors should not be used. If you use clear colors throughout a picture, the result can be too bright, even garish. Careful use of slightly duller colors will contrast with the bright ones and give color and tonal balance to your picture. For example, you can tone down an over-brilliant green by adding olive greens.

5 Complementary colors (see page 40) give balance to a picture. Also, if placed side by side, they add contrast and brilliance to a work. For example, if yellow is placed opposite mauve, the two colors complement each other rather than toning with each other.

Can I keep my mixes from getting muddy?

How do I know how much water to apply or whether I should use colored paper?

The application of water, the amount of pressure applied to your watercolor pencils, and the color of your paper will all affect the color you are using. Water will make the applied color brighter. Colored paper will greatly affect the intensity of your watercolor pencil colors and can be used to achieve various effects. Blue paper will tone down a color like yellow but will have little affect on red because it is a naturally dense and strong hue.

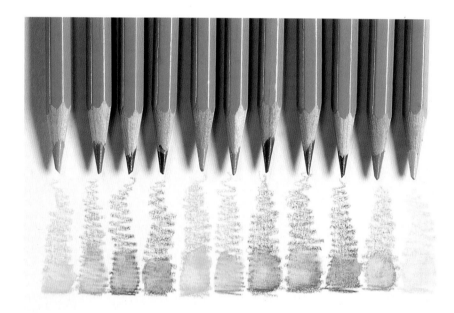

1 Colors that are close to each other on the color wheel share the same color "vibration." When mixed, they will stay clear and bright. These are toning colors—colors from similar ranges will modify basic colors without reducing clarity. Arrange your colors into families to see which colors work well together. From this array of greens, use the wonderful blue-greens and viridian colors for glass and ivy colors; a touch can also be useful for drawing water.

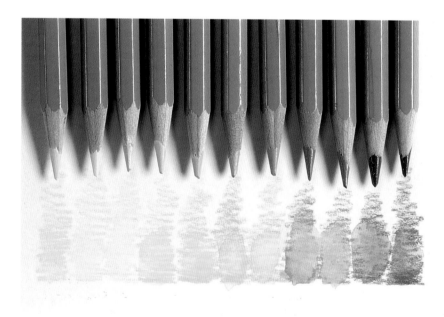

2 When you arrange your colors into families, you will realize that there is a huge range of yellows, from the lemon yellows through to the cadmium oranges, as well as the subsidiary ochre colors. The cadmium colors tend toward the warm reds, and the lemon yellows tend toward the green spectrum. Experiment with mixing colors to see what happens. Mix cadmium colors with greens to produce warm, slightly dull greens. Add lemon yellows to create vivid and lively greens.

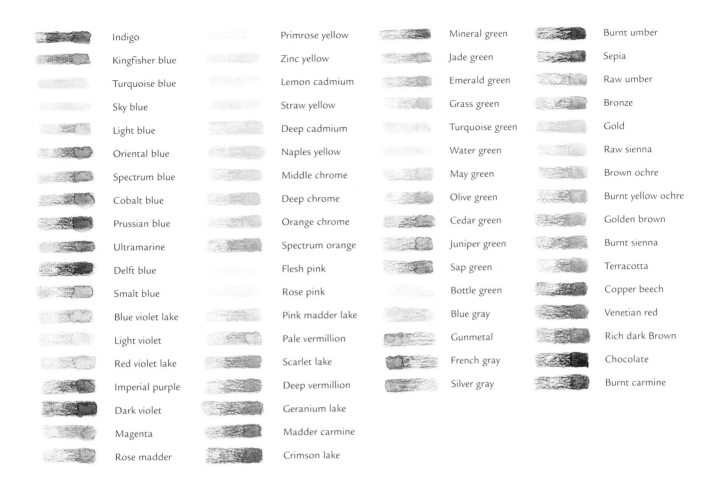

Indigo	Primrose yellow	Mineral green	Burnt umber
Kingfisher blue	Zinc yellow	Jade green	Sepia
Turquoise blue	Lemon cadmium	Emerald green	Raw umber
Sky blue	Straw yellow	Grass green	Bronze
Light blue	Deep cadmium	Turquoise green	Gold
Oriental blue	Naples yellow	Water green	Raw sienna
Spectrum blue	Middle chrome	May green	Brown ochre
Cobalt blue	Deep chrome	Olive green	Burnt yellow ochre
Prussian blue	Orange chrome	Cedar green	Golden brown
Ultramarine	Spectrum orange	Juniper green	Burnt sienna
Delft blue	Flesh pink	Sap green	Terracotta
Smalt blue	Rose pink	Bottle green	Copper beech
Blue violet lake	Pink madder lake	Blue gray	Venetian red
Light violet	Pale vermillion	Gunmetal	Rich dark Brown
Red violet lake	Scarlet lake	French gray	Chocolate
Imperial purple	Deep vermillion	Silver gray	Burnt carmine
Dark violet	Geranium lake		
Magenta	Madder carmine		
Rose madder	Crimson lake		

3 Draw small swatches of each color from your set of watercolor pencils. Have three areas on each swatch: lightly drawn, pressing more heavily, and wet. This helps you to see how the different colors will appear on the page; it will also familiarize you with the colors in your set. Arrange your colors in toned color scales. Draw dry and wet swatches of these to see what each pencil does. Some blues for, example, are more purple (Delft blue and ultramarine), while others are greener (Prussian blue and indigo).

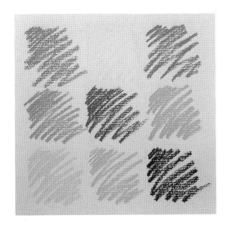
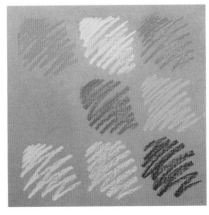
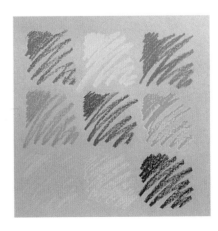

4 The paper color affects the appearance of your pencil colors, especially those that are light-toned or translucent. Make color charts to check the variations. Notice, in the examples above, that the warm brown and cold blue papers create a significant difference in the effect of the cool gray and yellow ochre pencils (bottom-left and center). The orange (middle-right) appears lighter on brown than on blue. The translucent bright yellow (center-top) is diminished in intensity by the underlying blue, but the red (top-left), which is a naturally dense, strong hue, is less influenced by different background colors.

How do I mix colors in watercolor pencil?

Mixing colors with watercolor pencils takes place on the page rather than on a palette. The mixing is achieved by layering many different colors in dry pencil and then adding water to blend them together. The pencils are very precise and are not well suited to loose and free-flowing work, but suited to intense areas of color.

When layering colors, try to get as much depth from each color as possible. Build the layers of color in the mix very gently and slowly. To keep colors as clean as possible, work with similarly colored pencils—those from the same area of the color wheel—and then add nuances from other ranges.

1 Draw the outline of your subject in a pale color that is in the light to mid-tones of the finished piece.

2 Block in areas of color in the pale range of those you need. Here, the base color is May green, a very pale green. Remember to leave highlights—the veins of the leaf—as clear, pale colors, such as white or cream.

3 Add water to the May green to bring out the yellow tones. Although not realistic, this will be a fine base color for building up other colors. Color the shadows to define the shape of the leaf, especially some of the very dark veins. The veins do not go right to the edge of the leaf—concentrate on getting their angles and spacing correct. Shade right up to the edge of areas to define complete shapes.

 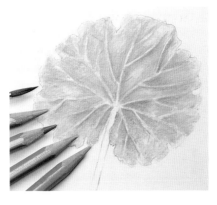 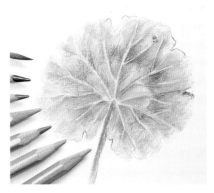

4 Wet the leaf again to create a base—closer to the color you want—on which to add and mix further colors.

5 It takes a long time to complete a picture. Patiently layer on color to ensure you achieve vibrant effects.

6 When layering, don't be afraid to go back and use colors you've already used—the buildup does not have to be regimented. If you do slip up and go over a very light area like a vein with dry pencil, pull away the color with plastic laminate. If you go over light-colored areas with a wet brush, wet it further with a brush and water, and then blot away the color. Notice the subtlety of the layers of colors—the composite green is beginning to look very real. See also how the colors fade toward yellow at the edges of the leaf.

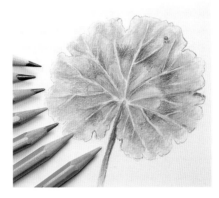

7 Once again, use a much darker color to put in shadows. Layering a lot of bright colors results in a far more realistic color, in this case a more natural green. Build up the area where the veins join together by filling in shadow detail. This will tone down the greens to a more natural color.

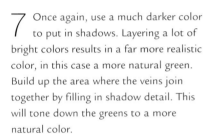 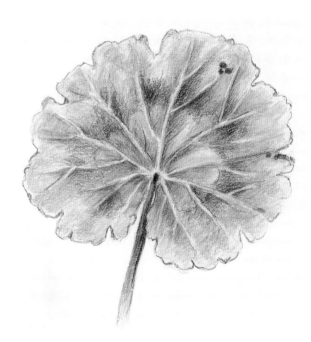

8 Draw the final details on the leaf with some complementary colors—deep browns, purples, and blues. These will lift the colors and improve the depth of color in the final painting.

9 The slow, patient buildup of colors has created a range and depth of color impossible to achieve with single pencils and water alone. Gradual blends and fine detail are also possible.

When I paint white objects, they look dull and flat. Do you have any tips?

If we try to draw white objects by thinking in terms of white and gray, the result will be clumsy and lifeless. Watercolor artists use "botanical gray," a mixture of ultramarine and Indian red. This produces a beautifully modulated gray, with both the warm red and the cool blue and with none of the dead quality of black.

With watercolor pencils, the colors cannot be watered down to nothing, so another solution is needed. Look carefully at white objects and you will see very little actual white. Instead, you will see a whole range of warm creams and ochres and cooler blues and mauves. Only the highlights will be pure white. By capturing all these colors, you will re-ceate the true appearance of white objects.

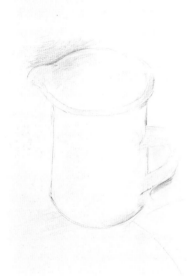

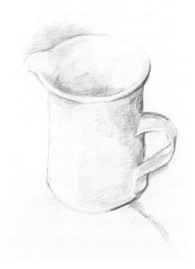

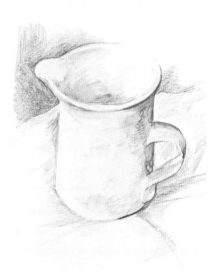

1 Complete your basic sketch, and look closely to see if you can find any areas of actual white. These are the highlights, the same as on an object of any other color. Everything else is a shade of blue, brown, gray, or mauve. Avoid gray, however, because it won't give you the colors you need. Define the absolutely white areas by making everything around them "not white."

2 Apply warm tones with a very faint color—flesh pink and some gentle yellows are good colors. It is always useful to think in terms of warm and cool colors, particularly when trying to capture whites. Areas of warm color should be pale, but you will find shadowed areas with no warmth at all. The bottom of the pitcher looks blue and cool rather than warm.

3 When drawing white objects, use strong side lighting to create a better picture. Define the contrasts between areas, rather than thinking in terms of areas of different colors. Look to see whether the edge of the pitcher in shadow is lighter or darker than the background.

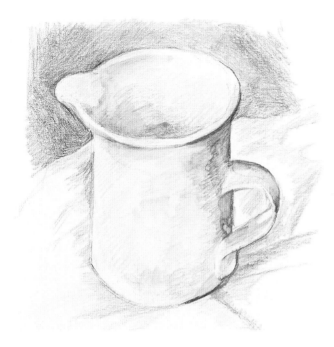

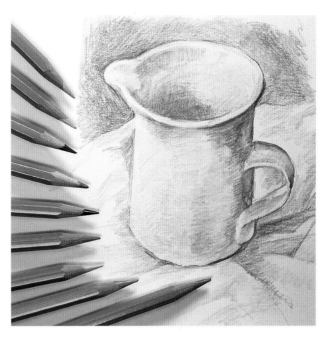

4 Apply the strong lines and contrasting areas with blue-violet lake, blue gray, and indigo. Rather than using gray, add some sky blue—which is quite a warm color—to create the areas of shadow. The cloth has cool, blue undertones, whereas the porcelain of the pitcher has warm tones. After initial washing in, be careful when adding more water. Some pencil work can look perfect when dry but too colorful when wet.

5 Here is a perfect example that shows the complex nature of white. A number of colors are used to capture a seemingly "white" pitcher on a "white" cloth.

6 Although the pitcher and the cloth are both white, almost nothing in this scene appears white. When you look closely, you see creamy and ochre colors, and some of the shadowed areas are very dark.

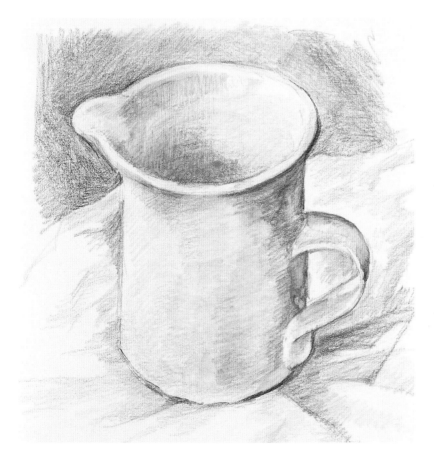

7 *Burnishing* is the term given to filling in any tiny little holes through to the paper that remain in your drawing. Use the lightest of the color pencils used in your drawing to rub color over the surface of the paper to seal it. This blends the underlying colors and leaves a glossy surface. This detail shows the kind of finish that burnishing creates.

When I paint white objects, they look dull and flat. Do you have any tips?

3
Depicting still life

A still life is not simply a wonderful exercise for an artist; it can also be a very satisfying completed picture in its own right. A still life enables an artist to set his or her own challenge. When working from photographs, the challenge is to decide what to leave out, how to manage the level of detail and how to crop a suitable scene and make a satisfying composition from the raw material. With still lifes, artists can arrange objects to suit themselves; from creating a satisfying tonal balance to arranging objects to make a dynamic composition, the artist is in control even before beginning a picture.

Side lighting can make a great difference to a still life, creating satisfying areas of light and shadow and making an arrangement much easier to draw. The secret with capturing light in a still life is to observe closely and to draw what is in front of you. Some subjects are harder to paint than others; white cloth, for example, presents challenges in capturing texture and the subtleties of color. No drawing challenge is insurmountable, though, using close observation and a gradual buildup to a completed effect.

Metal and glass present their own challenges, and this chapter helps you to deal with the bright highlights of shiny objects and the effects of light shining through glass.

Backgrounds can help to give a subject a context or to give prominence to light-colored subjects in the foreground. There are many different techniques to use, from patterned backgrounds to rubbing. This chapter looks at the advantages and disadvantages of the different techniques.

The first demonstration looks step by step at the creation of a still life incorporating many different surface textures and a bold color balance between bright red tomatoes in the foreground and areas of magenta in a decorative background cloth. The second demonstration tackles more complicated subject matter: glass bottles and jars and a white cloth.

Flowers present their own particular challenges—most importantly, how to keep colors clear and bright. The sunflower demonstration draws together and shows clearly the key skills in successfully painting flowers.

I find light in a still life confusing. How can I capture the light source?

Colors are bright and clear on the side from which the light comes. On the other side, colors are darker. The most important trick to capturing light is to define where the light is coming from and make sure that it shines on all of the objects in your drawing from the same place. The highlights will be those points nearest to the light source. They appear as white or very light-colored, depending on how reflective the surface is.

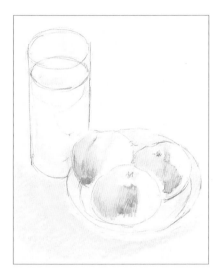

2 There is a lot of reflected light in a still life. For example, the bowl reflects light onto the underside of the apples, making them less dark right at the bottom than they are higher up. Be aware of all the shadows that the objects cast, not just the major ones. Light-colored or transparent objects are not always light-colored when you draw them; the clear glass filled with water, for example, has some very dark areas.

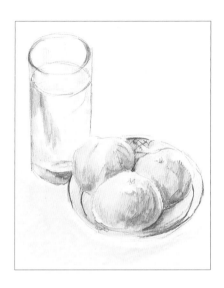

1 First identify the highlights; work around these and away from them. Decide which are the light areas in your composition and where the shadows are. Draw in the background to help define the foreground. This is important when objects in the foreground are white or pale-colored.

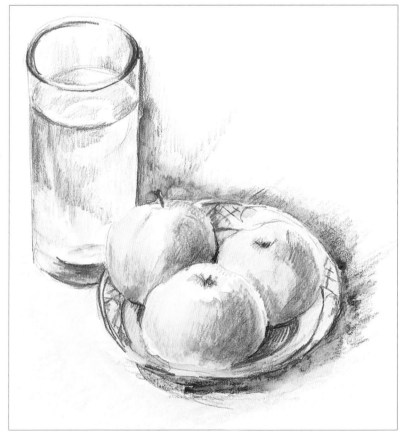

3 Layering a light color over other colors "knocks" them into each other. This technique, commonly used with color pencils, is known as "burnishing" and can also be used with watercolor pencils. Burnish the background, mainly with silver gray. Defining the background helps to capture the light in the foreground.

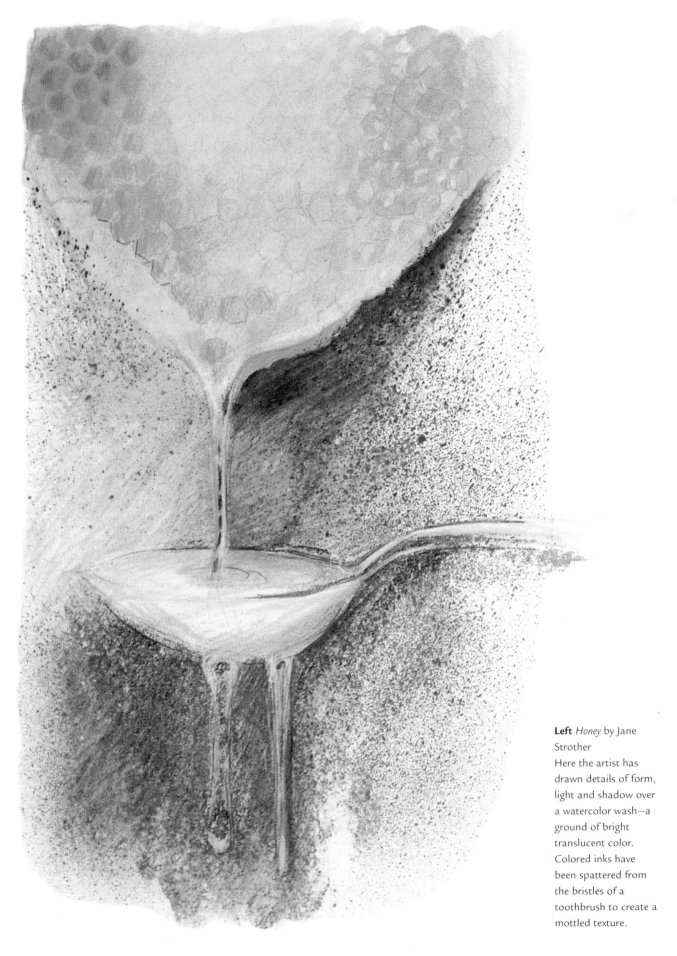

Left *Honey* by Jane
Strother
Here the artist has
drawn details of form,
light and shadow over
a watercolor wash—a
ground of bright
translucent color.
Colored inks have
been spattered from
the bristles of a
toothbrush to create a
mottled texture.

I find light in a still life confusing. How can I capture the light source? **51**

What should I consider when deciding on a background?

There are many ways of creating backgrounds: flat color, rubbing, some form of shading, a patterned backdrop, shadows, roughly sketched outlines of surrounding objects. The important thing is not to let the background overpower your drawing.

Sometimes though, a dark background can help highlight a light-colored drawing in the foreground. Never simply "fill in" a background just for the sake of doing one; it should be an integral part of the drawing and should add to it.

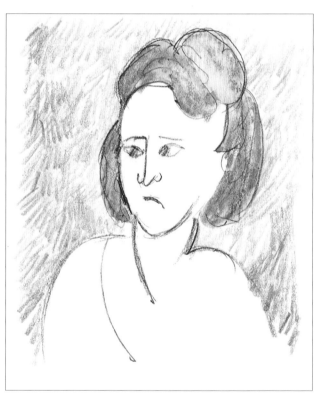

Use a patterned cloth as an inspiration, but don't feel that you have to copy every last detail of the material slavishly. Instead, let it inspire you (Oriental carpets are very useful for pattern ideas). If your cloth is very brightly colored, leave the drawing dry, as wetting may make it too prominent. The secret to a patterned background is to have it either lighter or darker than the foreground. Geometric patterns are easier to draw than floral ones. Take care with patterned backgrounds because, if they are too bold and bright, they can overwhelm a picture.

Crosshatching can produce a very effective background for a strong drawing, which it will not overpower. Vary the length and angle of the lines to create an interesting texture. This will contribute to the overall balance and harmony of the composition.

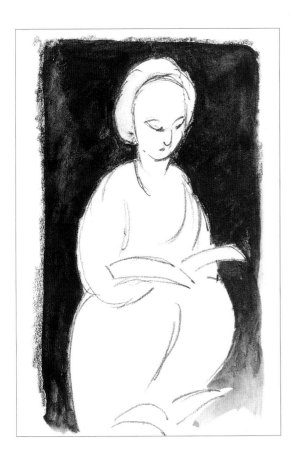

A dark background can work well, but watercolor pencils are not designed to produce a dark background on any scale, and trying to do this on a large scale is even harder. Rembrandt is famous for his dark backgrounds, but he was using a semi-opaque medium and brushes. Watercolor pencils, on the other hand, are semi-transparent and work through points, which makes it difficult for them to cover large areas with solid, dark color .

If using a shadowed background, the shadows must be consistent with the light source, or sources. They should also be below the objects you have drawn. Shadows can be very useful in giving prominence to a drawing and in situating objects in space. Remember that shadows fade the farther they are from an object; an apple, for example, does not simply have a circle of darkness of uniform intensity beneath it—its shadow will be darkest closest to it and less intense farther away.

RUBBING

1 Rub dry pencil marks with a finger to produce a more even finish for a background that is less likely to overpower the foreground. First, make pencil marks, using spiralling lines or short, overlapping parallel lines—whichever technique you prefer.

2 Rub the pencil marks with a finger to obscure some of the detail of the marks and to fill any spots that allow the whiteness of the paper to show through. This technique is excellent for creating a plain background that will not dominate.

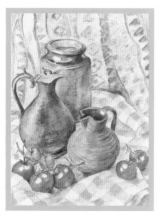

Drawing from live still life arrangements has a number of advantages over drawing from photographs and other kinds of drawing. When painting from life, your eye edits for you as you draw. You don't have the problem of finding that parts of a photograph are not satisfactory—with a still life you can make an arrangement that you are able to paint. Arrange objects so that they relate to each other. Use a cloth to soften hard table edges and backgrounds, or drape one over the back of a chair to give height to a composition. Decide whether you want to include table edges and whether you want to show them face-on or on the diagonal. Vary the heights of objects with books placed under a cloth. Use folds of cloth or pieces of cutlery to encourage the eye to travel around a picture. Check your arrangement by doing a few thumbnail sketches. This also helps you to decide on a landscape or portrait format.

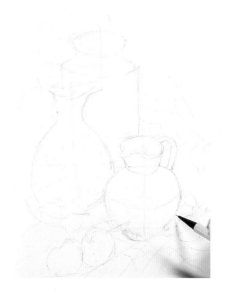

2 Natural objects are never quite round or regular. Draw exactly what you see, rather than trying to draw tomatoes as little circles, for example, when, in fact, they flatten on top and seem to divide in two. Start to color the shadows with a neutral color like blue violet. Look out for highlights and reflected highlights and keep them as clear, white paper. Begin to draw in the shadows to create a three-dimensional, tonal picture.

1 When drawing jars, vases, and similar symmetrical objects, draw central and horizontal guidelines; then work out roughly where the lines are on either side. Remember that the ellipse at the base of a cylindrical object will be closer to being a circle than the one at the top. If the top of a cylinder is actually on your eye line, it will look like a line, rather than an ellipse. Draw as many guidelines as you like—you can erase these later.

3 Draw a wet brush from the clean paper onto the color. Use clear water and start well outside the area of color that you are wetting to avoid getting hard edges. Or dab, rather than brush, water on to avoid "tidemarks."

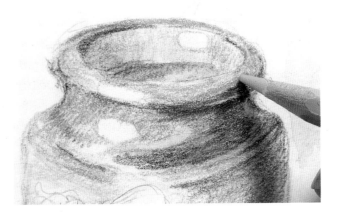

5 A glazed surface has many highlights and reflects light onto objects alongside. Leave all these highlights clear and bright.

4 Give the tomatoes very light shadows at this stage because you want to capture their bright red color. Experiment to discover which colors you prefer to use to put in basic shading, but beware of black because it will overpower any colors near it. Don't use too much gray either, for the same reason. Instead, look for positive colors in the shadows.

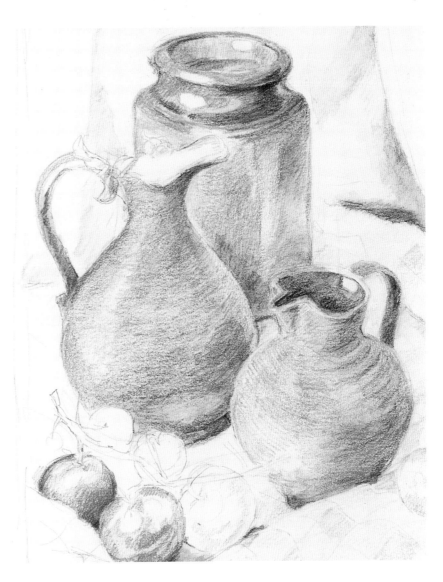

6 Examine different surface textures. The ceramic pitcher is unglazed on the outside but glazed on the inside; therefore, the highlight at the top inside the pitcher is bright and clear, but highlights on the outside are muted.

7 Build up color very gradually. Always use two or three pencils, and explore all the different colors that you can see, looking particularly for warmer tones. Even the coffee pot, although it has an unreflective metal surface, casts some light and should not be colored too heavily and darkly.

8 Build up the lighter colors, starting with the tomatoes. Use a warm undercoat of yellowy orange (middle chrome.) This will help to intensify the red.

9 Take account of the reflection of the yellow cloth as you gradually build up the red color of the tomatoes. Use an undercoat of May green for the smaller, unripened tomatoes.

10 You can use vibrant colors in a background, but take care that it doesn't take over the picture. You don't have to capture every detail of a background cloth. Instead, you can use what you have as an inspiration. Roughly copy geometric shapes and use them as a template.

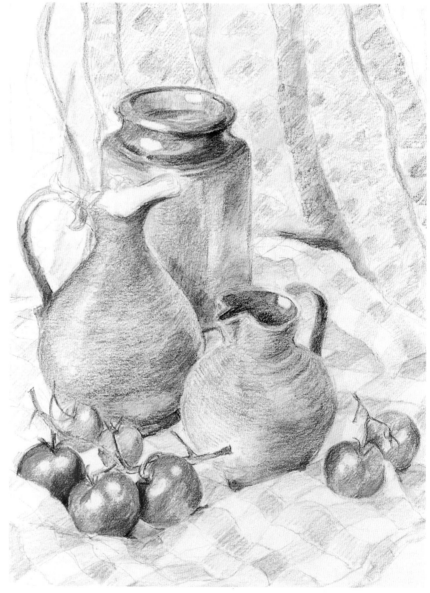

11 The magenta on the patterned cloth in the background tones with the tomatoes and prevents all the viewer's attention being dragged to the bright, red in the foreground.

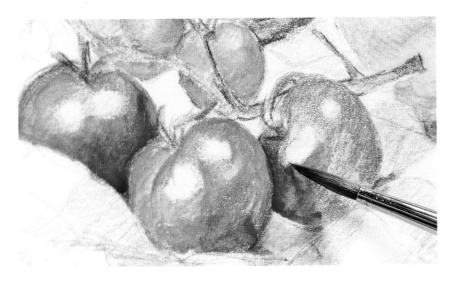

12 Take care when wetting not to lose detail. Draw most of the water off the brush by holding a tissue to the back of the brush and then dab, rather than brush, the water on. Enhance highlights by judicious dabs of water to strengthen the patches of color immediately alongside. Wet the tomatoes very delicately so as not to lose any detail. Wetting helps to bring out their rich color.

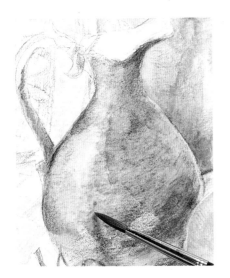

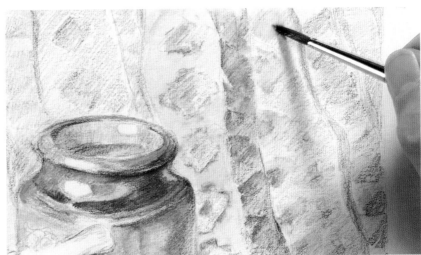

13 Similarly, wet the matte metal surface of the coffee pot to capture its texture.

14 Wet the background to give it the feel of a watercolor painting, or leave the background unwatered and matte so that it doesn't overpower the foreground.

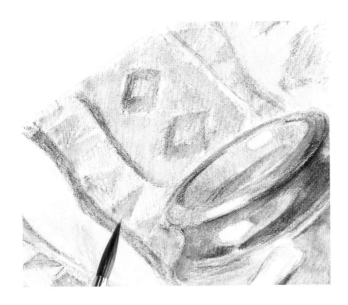

15 Wet every little area of color in the background separately to avoid blurring the colors. This background is more impressionistic than accurately detailed.

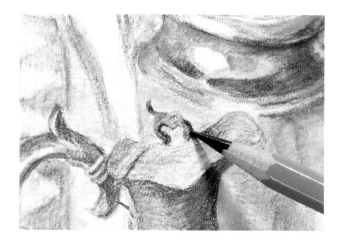

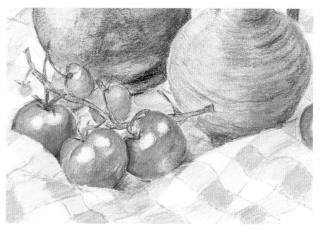

16 When putting in small details, search carefully for all the highlights and shadows. Although it is very small, the thumb hold on the coffee pot lid catches light and casts shadows in many different ways. Keep the pencil points very sharp for these fine details.

17 Draw the lines on the tablecloth using gray, rather than black. The contrast makes the lines seem black, whereas actual black would have been overpowering.

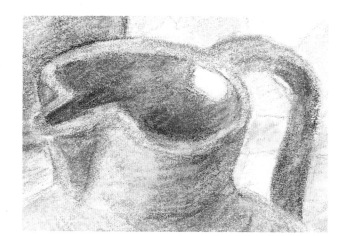

18 Capture the brightness of the highlight on the glazed inside of the pitcher with a strong contrast between clean, white paper and the color alongside. Use some color on highlights that are less bright, as on the matte surface of the unglazed outside of the pitcher.

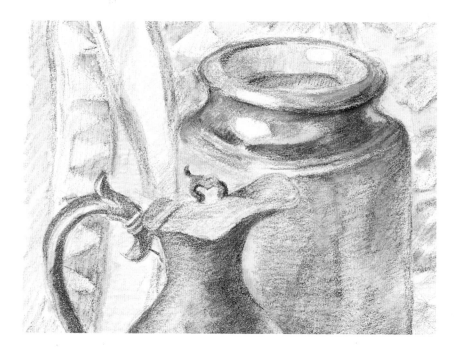

19 Surface texture influences how light is reflected. The highlights on the glazed pot are bright and clear, while on the matte surface of the metal coffee pot, they are much more muted.

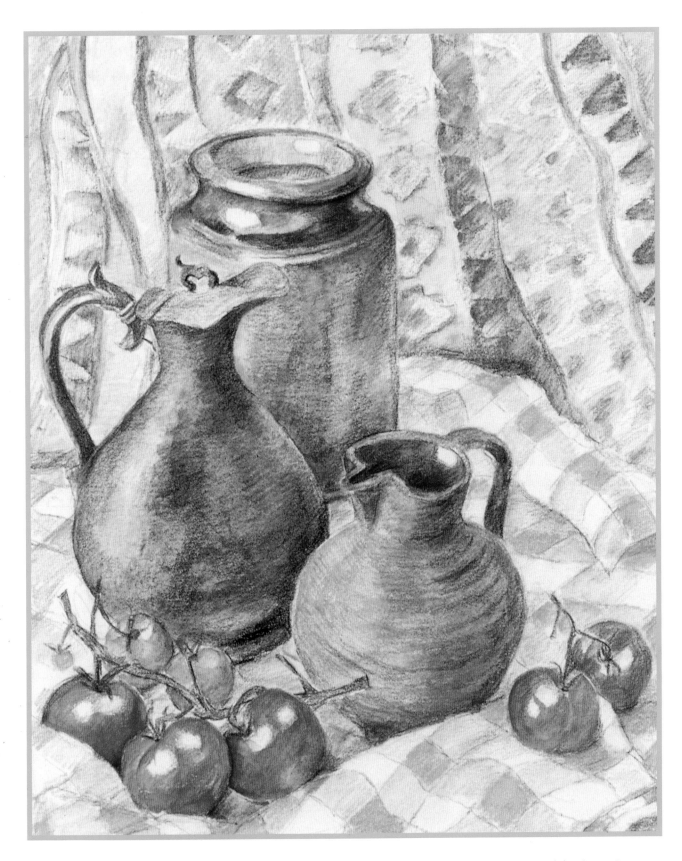

20 Look at both the arrangement of objects and the tonal balance in the final drawing. The magenta in the background cloth helps to prevent all the attention being drawn to the bright red tomatoes in the foreground, while the folds of the yellow checked cloth and the variation in the heights of the objects help to lead the viewer's eye around the picture. Be aware of different surface textures—the glossy tomato skin, the matte metal of the coffee pot, the table cloth, and the glazed and unglazed ceramic surfaces.

How do I paint textured white cloth?

Look closely at the cloth to see which colors you can see and whether these are warm or cold—with house lighting, colors are usually warm. Don't think in terms of whites and grays, but look for the ochres, mauves, and all the other colors which are there. Reflections from a cloth cast secondary highlights on other objects and on shadows. Some parts of a white cloth will be deeply shadowed. Decide first on the tonal values of the shadows and then add color to that depth.

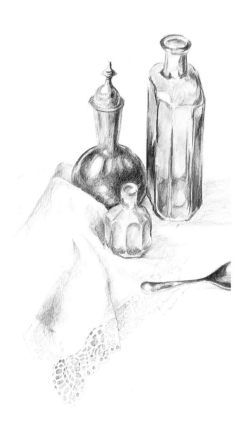

1 Draw the overall shape of the cloth before drawing the lace. Generalized holes for the lace will not satisfy the viewer, so draw the shapes of the holes relatively accurately, because different types of lace are distinguished by their patterns and shapes. Look closely to see what color you can see through the holes of the lace, and use this to draw in the background, which will also help to define the pattern of the lace.

2 Cloth has very few hard edges unless you can see the top of a fold. Use any hard edges you can see to help you define the cloth with shadow. Rub out all guidelines because, with cloth, you want soft lines, rather than hard edges. Use yellowish colors and even flesh pink, but avoid primrose yellow as it is too stridently yellow.

3 Even where you can see a fold, the area on top is often not hard-edged, but quite delicately shaded. Soften folds gently using delicate strokes of faint shadow. When adding the basic ground color to the cloth, shade quickly and roughly; the light color of the pencil will blend with the light color of the paper to create texture. You do not have to add water to this base color—the pale color against white will capture cloth more effectively than stronger, watered tones. If you do add water, work from a light area toward a dark, so that you do not pull shadow colors onto light areas.

What are broken colors, and how do I use them?

"Broken colors" are colors that are mixed by making small marks in different colors that blend optically to create a new color. In a sense, this is an optical illusion: the eye "sees" the colors as combined but also sees the texture of the individual pencil marks. However, too much water or too much brushwork can spoil the effect and create a muddy, ill-defined area, so take care when adding water.

1 You can use broken colors—both with toning colors and with complementary colors—to produce a scintillating surface. Broken colors is a pastel technique, but watercolor pencils contain much strong color and can be used in the same way. Bring out the strength of the color by wetting the lines, but take care to dab on only a small amount of water—don't smear the colors together.

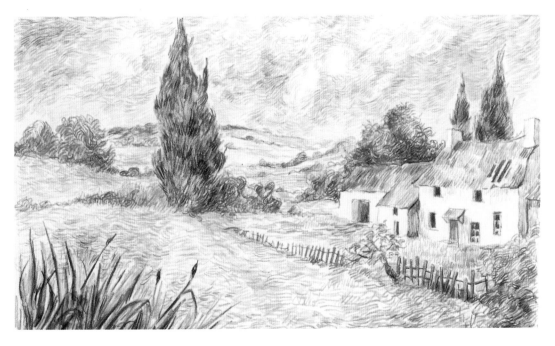

Left In this French village scene, Hilary Leigh has used colored pencils to achieve a Van Gogh-style effect. The artist has used broken colors and the visible pencil marks give the picture a vibrant texture.

How do I depict different kinds of metal?

Metal reflects blue, yellow, or even pink light, depending on whether it is steel, copper, or some other metal. Look closely to see what colors make up the shadowed areas. Don't be tempted simply to head for blacks and grays for silver metal surfaces, as these colors will deaden your drawing. Instead, use blue-grays and indigos—darken and round these with a dull brown, like burnt umber, or warm them with light yellows and flesh pink. If the object is very shiny, "warm" the colors using burnt carmine and dark violet.

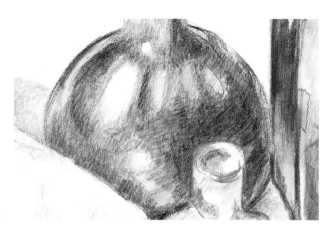

1 Outline highlights with a graphite pencil. Then decide if the colors you see are warm or cold. Look carefully to see where the white of the cloth has been reflected, and think in terms of smooth-edged areas of color. Capturing the shine of metal depends on contrasts, so define these as strongly as possible.

2 The highlights on the spoon are slightly colored, not pure white. Because it is satin-finished steel, the reflections fade gently on the edges—capture this satiny feel by streaking color across so that there is no absolute edge.

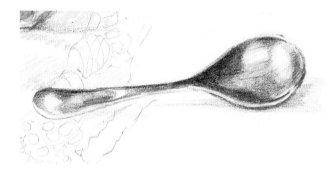

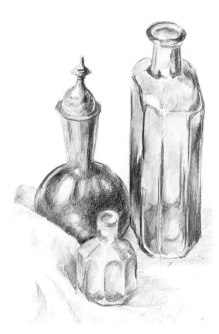

3 The bowl is the darkest part of the spoon, compared with its length and the spoon's edge is made up of two lines. The cream lace results in slightly warmer reflections along the length of the spoon—fractional areas of warm, yellowish colours. Use a very sharp pencil to define details. If working on a very small scale, do not wet the pencil marks. Dry pencil also captures more successfully the satin finish of the metal and the way in which it reflects light.

4 Add water to give metal objects a shinier appearance by obliterating most of the pencil strokes. Work from light areas to dark, and keep the edges of areas crisp, especially if you are painting a highly reflective surface. If the item is slightly silky, as here, blur the edges gently.

How do I duplicate the reflections and transparency of glass?

With glass, try to ignore your preconceptions and draw only what you can see. Because glass is translucent, it is tempting to paint it in very light colours, but in some parts glass can be very dark. Some of the rules for drawing water (*see* pages 104–117) also apply to glass, since it has curves of flow lines and reflects light in much the same way as clear liquid.

Glass is a constantly surprising subject—alongside the dark shadows of thick glass, you will often find an unexpected reflection, showing a very light color.

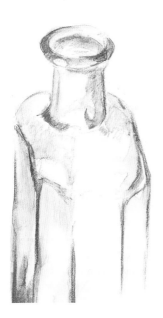

1 Sketch the outline of the bottle and mark the highlights faintly with a graphite pencil. Look next for the darkest areas, often found round the neck of a bottle, or at the base of a jar—these are points where you are looking through very thick walls of glass. Ask yourself whether you are seeing a predominantly dark blue or dark green color.

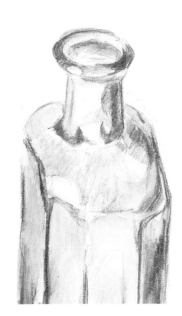

2 Gradually layer colors to deepen them. As you deepen the darkest colors, you may have to add mid-tones for the lighter areas. Many of the darkest areas have light reflected close by them, and dark shadows are sometimes broken up by reflected light, as on the right-hand side of the bottle. Use plastic laminate if you need to clean highlighted areas.

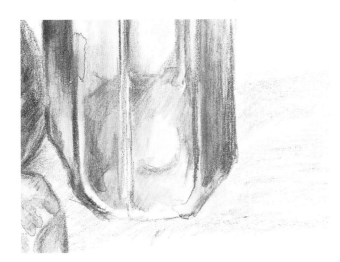

3 Wet the picture to make the glass look more realistic, but take care to wet discrete areas separately. Work from light to dark, and rinse your brush after each stroke. Continue to observe all the curves and lines, which you marked initially in pencil.

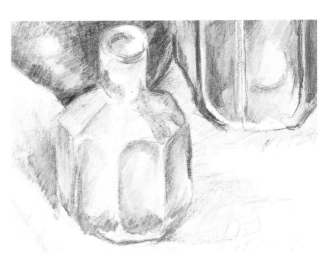

4 The smaller bottle is a bit grubby, so it is less reflective. The bottles cast light on shadows—in this picture you can see this most clearly on the cloth to the right of the small green bottle.

I feel my drawings are quite "flat." Is there a simple way to add texture?

An effective way to add texture and interest is to use shavings taken from pencil points and to mix them on a separate surface, away from your picture. You can then sprinkle these on your drawing, distribute them evenly, and fix them to the page with a wet brush.

1 Use a craft knife to shave fine scrapings of color from the points of watercolor pencils. It is easiest to do this on a spare sheet of white paper, so that you can see what you are doing as you mix the colors.

2 When mixing colors this way, follow the same guidelines that you would when mixing them on the page: use toning colors—neighbors on the color wheel—rather than complementary colors from opposite sides of the color wheel.

3 Sprinkle the shavings onto the wetted areas of your picture where you would like to use this effect.

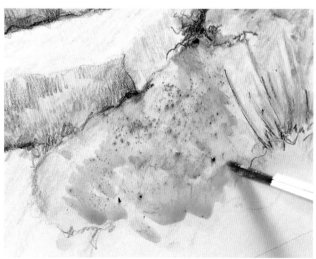

4 Use a wet brush to dab the shavings. Spread some of the color around, while at the same time fixing small particles to the picture to add texture.

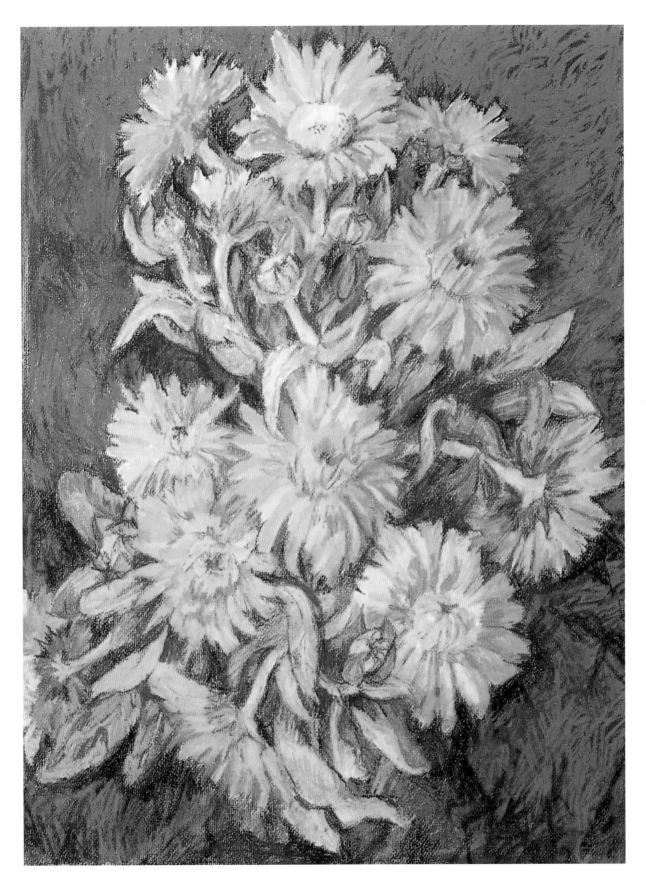

Above In this drawing of marigolds in soft pastels on Ingres
paper by Hilary Leigh, a dark background and broken color have
been used to offset the brilliance of the flowers in the foreground.

I feel my drawings are quite "flat." Is there a simple way to add texture?

This still life is set up using glass bottles and jars, which tone with the dark violet blue of the grapes and figs and the heavily patterned blue of the saucer. A cut-open fig offers a gentle focus point in contrasting magenta, while the vine leaves create a tonal contrast in olive and yellowy green. In this way, the whole color spectrum is covered.

The folds of the tablecloth give a sense of harmony to the composition by uniting the different items into one cohesive whole.

2 Once the main drawing is complete, start adding detail and color to the jars, concentrating on the dark areas. Pick out the colors of the objects behind the jars, such as the dark blue of the rear bottle and the viridian green of the glass jar in front of it, to develop their translucency. Deepen the colors where the glass is thickest. The edge of each glass object is defined and the flat facets of the rear bottle cast uneven colors through the jar in front.

1 Sketch the objects in graphite pencil to establish their position on the page and their relationship to one another.

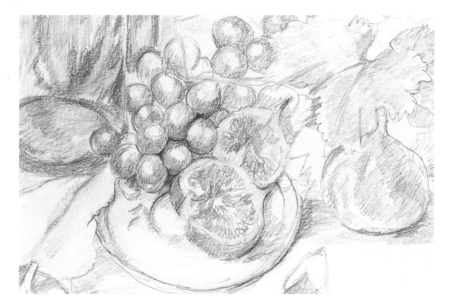

3 Build up the base colors of the rest of the objects in the composition. Work lightly at first to establish the highlights and shadows. Detail each grape individually, and note where the highlights fall on each one. Make sure that you have the shape and shadows of the saucer as accurate as possible before you begin to draw the pattern. Add colors lightly and let their richness emerge when you add water. Build up the seeded areas of the fig with loose lines of color to create the impression of individual seeds.

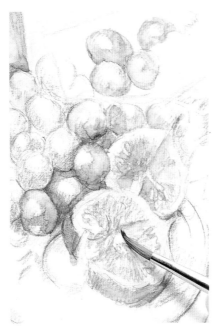

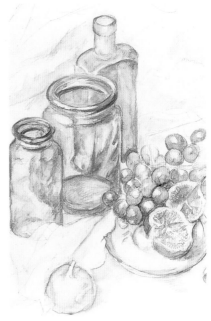

4 Add water to the drawing, always working from areas of light to dark. Observe carefully the shapes created in the shadowed areas of the glass; these are vital to drawing realistic glass objects. The water will also help to give the glass a smoother finish.

5 Dab water into every one of the seeds rather than washing over them. This gives a sense of individuality to each seed and creates a contrast of texture with the smoothness of the glass and grapes.

6 After the initial watering, you will see clearly the strongest areas of color. Build up the color on the grapes with blue-violet lake and dark violet, and then add water in smooth washes to maintain the sheen and texture of the skin.

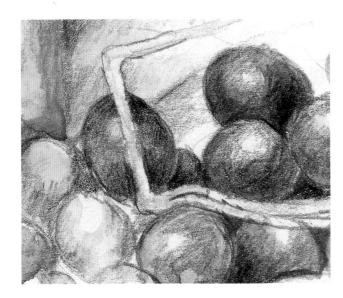

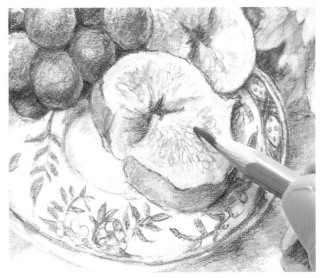

7 Add dark violet, dark blue, indigo, chocolate, and burnt carmine to the grapes to mold the spheres and enhance their visual warmth. Reduce the areas of highlight slightly so that they do not stand out too intensely from the darker tones. Add blue violet lake and light mauve to the highlights to soften them, and leave a slightly pale edge on the upper side of each grape to contrast with the dark underside and emphasize the curves.

8 Intensify the colors of the split fig. Use a sharp pencil to accentuate the shadows between the seeds. This detailed line work will offset the precisely defined pattern on the saucer. The blue-pink of the magenta pencils also complements the purple of the grapes.

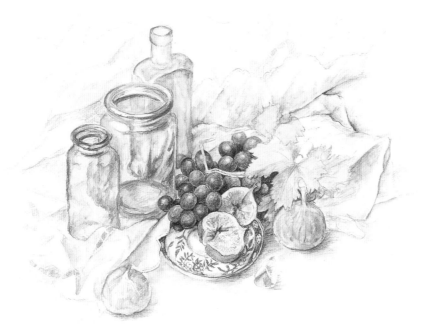

9 The bold color values of the grapes and the bottles mean that the figs, the split fig, the leaves, and the cloth need to be strengthened. Add color gradually to bring up the balance and so you don't overwork the whole drawing and diminish the definition of the objects.

10 Gradually add color to the base of the figs using russet, ochre, and olive undertones, but do not allow these colors to overwhelm the purple base color. Suggest a yeasty bloom by heavily burnishing the underside of the fig with white pencil. Apply the layer of white firmly to produce a glossy surface, but be careful not to let the white obscure the ribbed detailing in the skin of the fruit. Give the cut quarter of the fig a much darker arc of rind, and just hint at the remains of white seeds on the inside.

11 Complete the color balance across the drawing by adding some color to the white of the cloth and the table. The white section of table on the side of the cloth is a warmer hue than the tablecloth itself; a light shading of ochre for this will contrast with the blues and mauves where the tablecloth is in shadow.

12 For the detailed *broiderie anglais* on the cloth, draw each hole and color it lightly. Carefully add water with the tip of the brush, staying within the lines of each hole. Highlight the relief of the stitching by shading slightly round it and letting it dry. Use this method for both the embroidery and the scalloped edges of the cloth.

13 Carefully detail the crisp vine leaves to contrast with the smoothness of the glass and the softness of the cloth. Draw the serrated edges accurately, and be sure not to soften the detail with washes. The warm ochre mixed with olive bronze in the leaves contrasts very effectively with the purples, blues, and viridian greens in the rest of the painting.

14 The colors of the glass shine onto the white cloth, creating a turquoise glow behind the glass. Emulate this by roughly wetting these areas, which enhances the watercolor effect and deepens the richness of the colors.

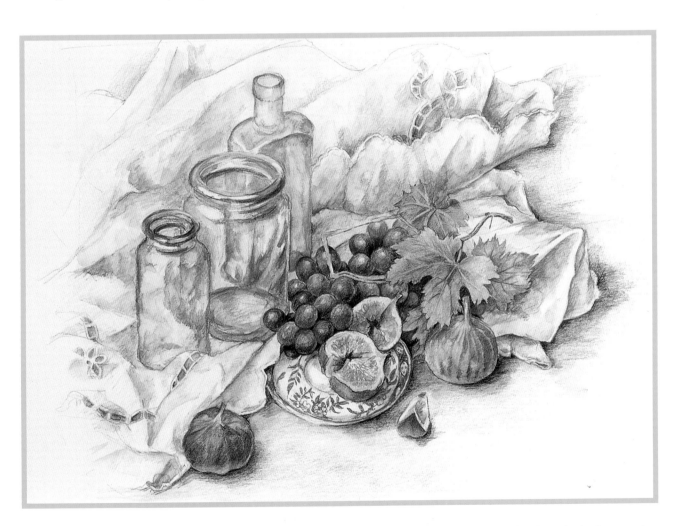

15 Finish the painting by intensifying the shadows around the objects to ground and harmonize the composition. Add a second coat of color and water to the objects in the foreground to give them a greater sense of presence.

How do I re-create the bright quality of a flower's color?

Flowers reflect two different sorts of light. On its outer surfaces, a flower reflects the shadows of its surroundings; but in its center it reflects its own color, creating a wonderful intensity of color. Use warm, toning colors—not cool, shadow colors—to create depth, and your flowers will look bright and clean, rather than dull and muddy.

There are no hard and fast rules, so experiment to find which way of dealing with shadows suits each variety of flower.

1 Shade in the negative space around the flower—this gives the petals prominence and brightness. Shading the background shows off the white flower edge and helps to balance the shadow on the flower itself.

2 Leave the edges of the flower white. Do some test strips on the side of the drawing to choose the right color—almost entirely magenta in the case of this cyclamen. Begin to apply color very gently. The effectiveness of drawing flowers lies in not putting in too much detail.

3 Work along the line of the petal rather than across it. Add darker shades of the basic color to the petals to keep the overall color of the flower clear and bright. Magenta is a bold color to begin with, so deepen the tone by layering more of the same color on top rather than using different colors.

4 Lay a warmer hue over the top of the flower. Heighten smaller areas with an overlay of pink madder lake. Deepen the color at the bottom with a touch of Imperial purple. Stroke the color in, right up to the edges, to give the impression of the color creeping upward. Use the same toning purple to create this staining effect—blues would be too cold and heavy.

I feel my leaves and stems often spoil my flower pictures. Do you have any tips on how to draw them successfully?

Look closely at the specific leaves you are drawing—don't simply draw general impressions of foliage. Every leaf is different because of the way it twists and grows. Plastic laminate is very useful for picking out veins on leaves. Avoid having a mass of green in the picture by leaving out some leaves to simplify your composition, or to make flowers more prominent. Always make sure that your stems look robust enough to support the weight of the flowers; it is a common mistake to draw slender stems that are incorrectly proportioned.

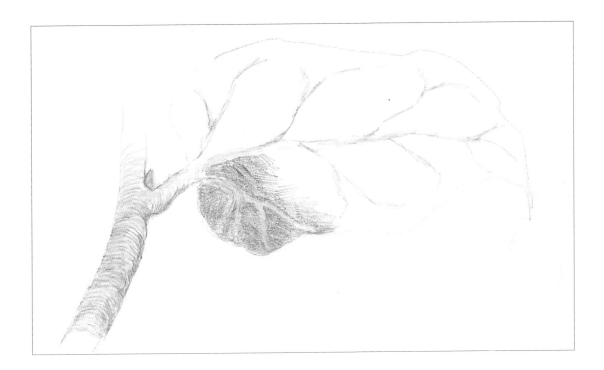

1 Notice particularly the angle at which the leaf stalks are attached to a stem. Look carefully at the angles of the veins on the leaf and see if they go right to the very edge of the leaf. Be aware of serrations on the edge of the leaf, and the ways in which the leaves are contorted. Achieve natural greens by layering many different greens over each other. The surface of a leaf is not flat, so there are small areas of shadow and highlights on any leaf. If you inadvertently run over a vein or other highlight with a pencil, you can use plastic laminate to lift the color.

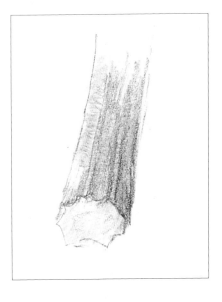

2 Examine the particular stem you are drawing. Does it have definite facets, or is it simply round? Contour shading—drawing lines that follow the contour of what you are drawing—across a stem, rather than along the length of it, works because it emphasizes the girth of a stem, without confusing its outline. Pay attention to the shadow along one side of a stem and the light that falls on the other side, as well as to the light reflected and the shadows cast by leaves and leaf stalks. If you make a stem too thin, you can lift the line with plastic laminate or a wet brush and a tissue, and redraw it in the correct place before using a wet brush to fill in the original incorrect line.

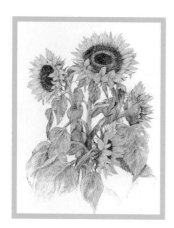

With flowers, sketch quite quickly initially to capture the spontaneity of the subject. Pay attention to achieving the correct proportions, especially for the stems, which should look fleshy enough to support the size and dimensions of the flowers. Leave out some of the background leaves, if you like, to focus on the flower itself. In this case, the bold, vibrant sunflowers are the most important element—the leaves are secondary. Focus on individual petals rather than drawing an unidentifiable fringe, but avoid too much detail on petals. Work with families of colors to preserve the clear, bright color of flowers. Wet your picture carefully to keep the different areas of color separate. Choose points of focus, and use the tip of a wet brush to draw attention to these areas by strengthening their color with a dab of water.

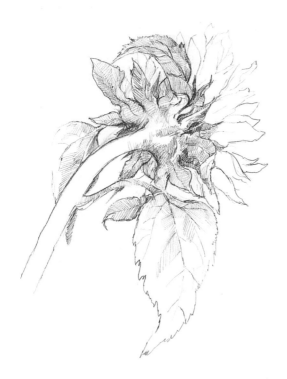

2 Some of the petals obscure the face of the flower; not all of them are outwardly unfurled. Try to be accurate, but do your initial sketching quite quickly—too slowly, and you will lose the spontaneity. Also pay attention to the sepals hanging down from the back of the flower. Sketch in the positions of the leaves and stalks at this stage—make sure that your stalks join up with the flowers.

1 To draw flowers successfully, you have to know how they are composed. Observe a flower closely from every angle to see how all its part fit together. Draw rough, initial sketches, looking for the individual shape of each petal. It is the unique qualities of the petals that make the flower look lifelike.

3 Unless you want absolute botanical accuracy, don't worry about losing count of the exact number of petals, but make sure you feel the curve of the petals you are drawing. If you are drawing yellow petals, use a handful of pencils within the same color "family." Color the yellow petals first because they use the lightest, brightest color. Apply color fairly heavily, as the petals will look light again once the darker colors are in place. Draw individual petals, but do not attempt to capture every nuance of shadow on each petal—overworking will muddy the whole effect.

4 When painting flowers, put down as much color before wetting as possible. Note where the veins come out on the leaves—they do not necessarily emerge uniformly opposite one another, as one might assume. As with the yellows for the petals, work with a whole "family" of greens. You may choose to leave out some background leaves to balance your painting as a whole. It's very rarely possible to include everything, nor is it necessary unless doing a botanically accurate illustration.

5 Don't make all leaves follow the same design because each one will look different, depending on how it is hanging. Notice that a petal comes down to close to a point at its base.

6 For texture, dab water onto each tiny area of the flower, rather than using large brush strokes. Remember to wet discrete areas separately to avoid muddying your colors. When you have wet one area, move to an area on the other side of your picture to stop colors from running into each other. Keep colors separate to capture the vibrance of flowers.

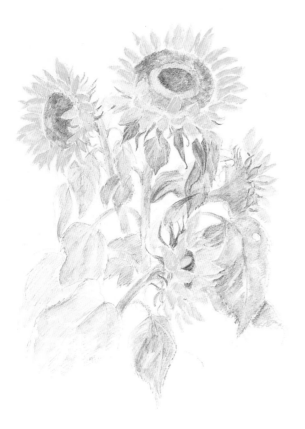

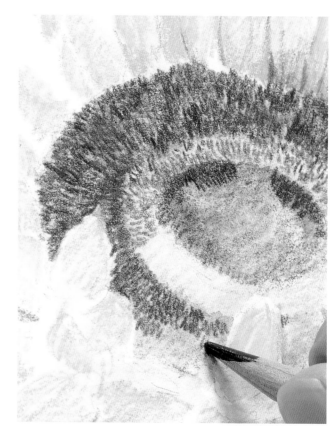

7 Wet the picture all over, taking care not to merge the colors. This provides a good base on which to start layering pencils. When you start to work with pencils, look again at the arrangement and then at your picture to see the areas that need darkening.

8 The center of a sunflower has a wonderful texture. Capture this with small, coarse pencil marks. Scribbled, zig-zag lines express the furry texture of the outer edges of the center. In the middle ring, use lots of little dots for texture. Think of the qualities of the colors you are using—chocolate, for example, is warmer than burnt umber because it's on the red side of the family of brown colors.

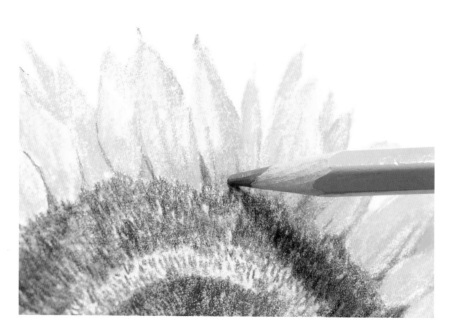

9 Use a sharp graphite pencil to define some of the petals. Graphite pencil is very useful for adding a tiny bit of extra detail, but be careful because, unlike watercolor pencils, it leaves a shiny mark. Use chocolate brown to add shadows to petals. Add burnt carmine for touches of really deep emphasis.

10 Burnish and blend dark colors by working heavily over the top with a lighter, dry pencil. Create other points of emphasis by working with the tip of a wet brush. This draws the eye to the most interesting features of the painting and creates the feeling of movement in the flowers. Don't overwork the petals, as this can make them look muddy. Capture their essential shape and feel but not every single detail.

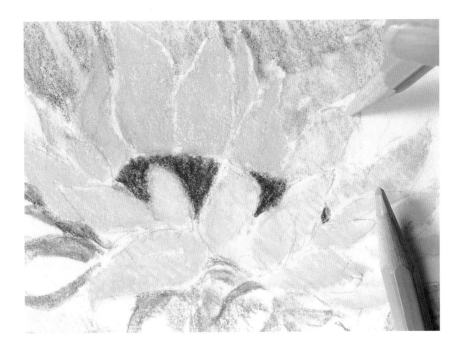

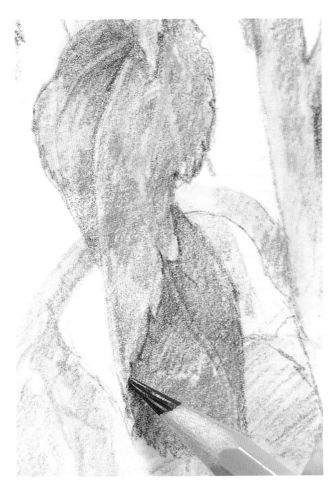

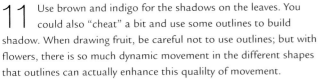

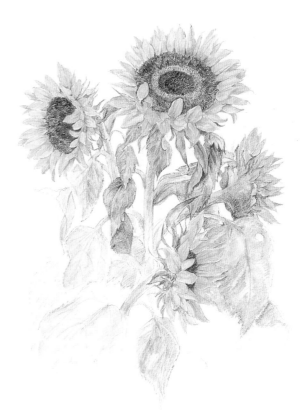

11 Use brown and indigo for the shadows on the leaves. You could also "cheat" a bit and use some outlines to build shadow. When drawing fruit, be careful not to use outlines; but with flowers, there is so much dynamic movement in the different shapes that outlines can actually enhance this qualilty of movement.

12 You don't have to put in all the leaves—you could leave some out to make the composition more open, rather than having the sunflowers up against a mass of green.

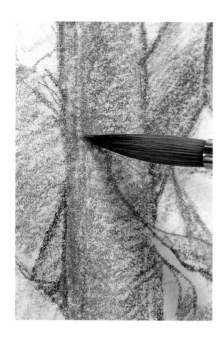

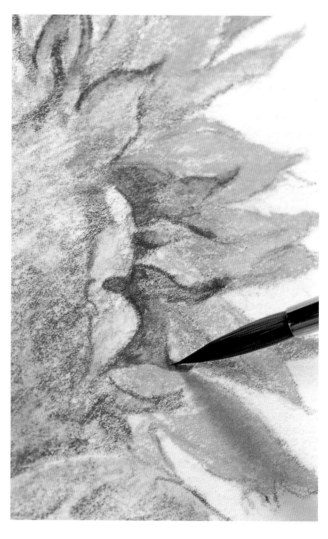

14 Use the fine point of a wet brush to slightly darken certain points for increased contrast. Wet the points on the backs of the sepals and bracts for added impact. Wetting has more impact than using a dry pencil.

13 Stalks should be proportional to the flowers that they support. If you have made a stalk too thin, lift the line with a wet brush and a tissue and redraw it. Use wetting to repair the groove left behind from having pressed too hard.

15 After the initial wetting of the ground color, use a wet brush to tighten and highlight aspects of the drawing. These points of focus enable the eye to focus, preventing a sense of blandness, and giving rhythm and movement to the picture as a whole.

16 When drawing stems, pay attention to how wide they are. Sunflower stems in particular are thicker than you might expect. With leaves and stems, the deepest shadow is not always on the edge farthest from the light source, as the leaves and stems reflect some light onto each other.

17 There may be two or more tiers of petals on a flower. Check which petals are in the light and which aren't, and see whether the tips of petals curl over. Use deeper yellows and ochres for the main areas of shadow on each petal. Using toning colors like this for shadows helps to capture the intensity of color in the centers of flowers, where petals reflect light onto each other.

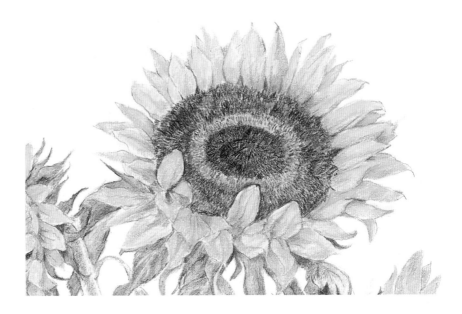

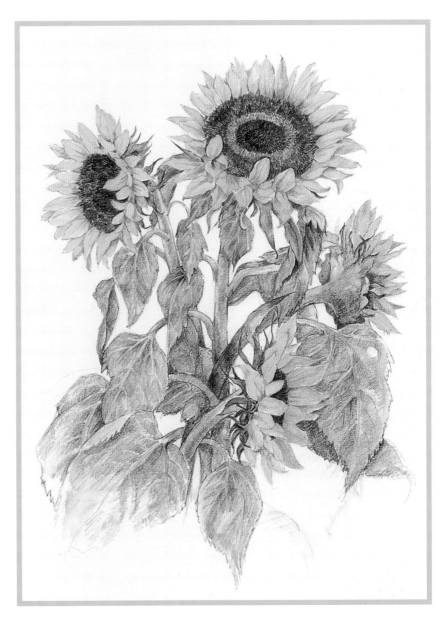

18 There is a lot of interesting detail at the back of a sunflower, so you might want some of them in profile or facing away from you in your arrangement. If you include a vase in your drawing, relate the vase to the surface on which it is standing, as you don't want it to look as if it's floating in mid-air.

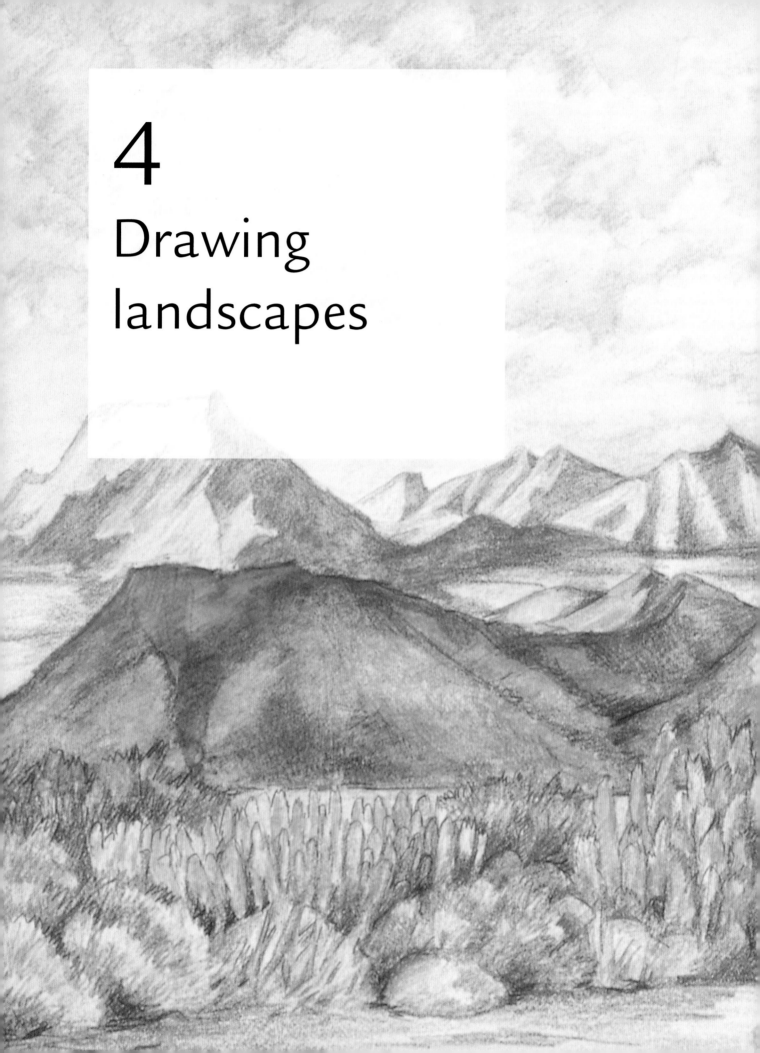

4
Drawing landscapes

There are many techniques to master on the way to becoming an accomplished landscape artist. Here you will find many tips to help you become a better landscape painter, from how to capture the differing qualities of light in a scene under different kinds of skies—from stormy to clear blue—to how to use the greens in a set of watercolor pencils to create composite, realistic greens that accurately reflect the colors in a landscape.

While perspective is of vital importance in drawing a townscape, achieving a feeling of distance in a landscape has less to do with perspective and more to do with changes in color and detail. Objects in the background appear much less detailed than objects in the foreground, and a drawing should reflect this. Colors and contrasts become muted as they recede into the distance, and weather conditions affect these changes.

Working from photographs has its uses. In fast-changing light, a photograph can help stabilize an otherwise very confusing scene. Working from photographs also helps you develop your ability to assess the "picture potential" of any scene. There is nothing better, though, than getting out there and sketching on site. Take photographs of your selected scene but also make sketches. These will help you give your painting immediacy, which may be hard to achieve with just photographs.

Mixing natural colors—especially greens—with watercolor pencils can be quite a challenge. The secret to capturing your subject matter, whether it is a tree, a lawn or a landscape, lies in layering your colors and gradually building them up to create a realistic effect. Familiarity with the colors in your set is the key to this, and experimenting with combinations on a piece of scrap paper as you work is very useful.

How do I choose which part of a scene to draw?

If you are working from a photograph, choose the part of the scene will make the most effective composition. In this case, crop the photograph to remove the boring expanse of mud in the foreground, and move elements around to bring objects or people into the frame you have selected. You could also alter the way in which these elements relate to each other. When looking at a scene in life, think about it in the same way.

1 A photograph can serve as an excellent starting point for a drawing. Do not copy it slavishly, but use it as a guide to create your own interpretation of the scene. You can even rearrange a few elements to make it a more powerful composition.

2 Isolate the yachts in the foreground and middle ground and the hills in the background with a pair of L-shaped pieces of a card. This provides visual interest, minimizing the featureless foreground and making the cluster of yachts the focal point.

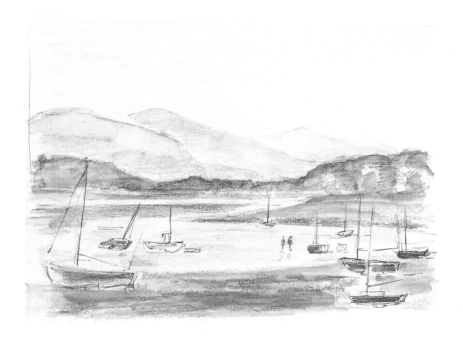

3 Draw a rough color sketch of the yachts, rearranging them to lead the eye around the picture. Bring some people into the scene to create further interest.

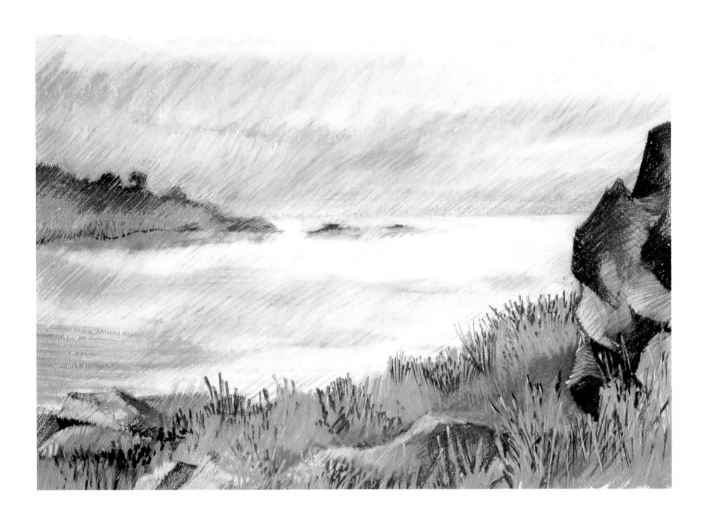

Above In this seascape, done with pastel pencils by an artist of the Cambridge School of Art, colors have been layered to achieve a subtle effect.

Right
In this drawing by Hilary Leigh, a sense of distance and space have been created by decreasing the intensity of color and lessening the clarity of line toward the background.

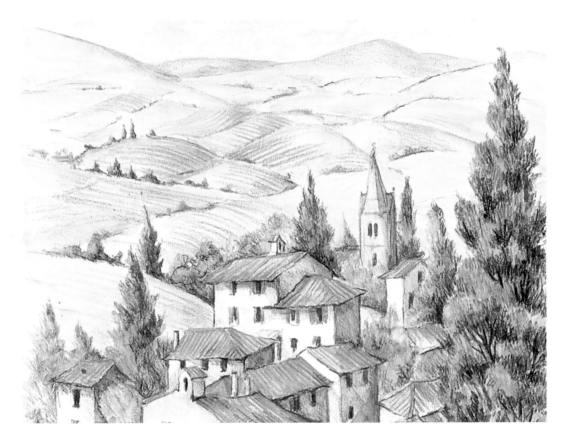

My greens look artificial. How do I make them look more natural?

If you have a reasonably large set of pencils, you can vary your greens sufficiently to give the illusion of natural greens. Most of the greens that you see in a scene or on a plant are mixtures, very often with earthy colors like ochre and olive predominating.

Greens in the distance tend to separate into their component parts of ochre and a mauve-blue. In the background, where detail disappears, skim over your greens with a coating of smalt blue, or blue-violet lake to soften the effect. Foreground colors will usually be warmer and brighter. Bright greens can be modified with earth colors, such as ochre and olive.

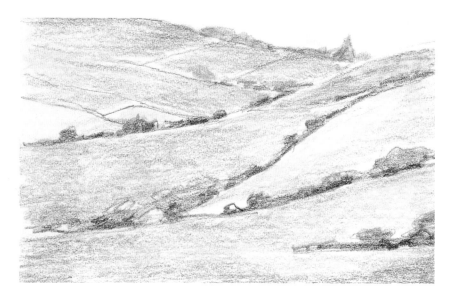

Distant greens require fewer actual greens and more ochre tones. "Haze" the greens with a bit of smalt blue, a mauve-blue, or actual mauve. Add olive greens toward the foreground where greens become more dominant. Use warm yellows even closer forward. Keep the colors slightly muted because grass is not bright—start by using May green before toning it down with olive green. When the wind is blowing, grass has a silvery tinge. Color the grass fairly lightly toward the background, and introduce stronger greens as you come forward. For trees, use a color like cedar green or, if farther back, add touches of smalt blue or Delft blue.

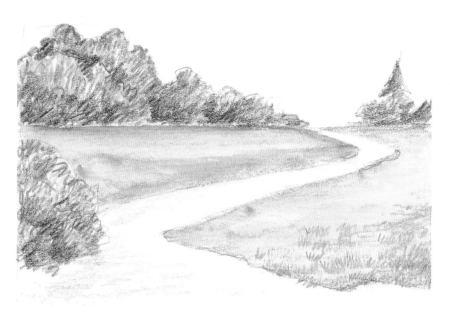

Think of the color of grass as bands of contour coming toward you. Start at the back with olive green—if it's very bright, you could add a bit of May green or yellow. Olive green is a good choice for well-watered lawns. Deepen the color as you advance. With mown grass, you tend to see a flat, smooth expanse rather than individual blades. A bit of indigo in the mid-ground and at the hedge bottoms will help to anchor them. Draw in the shadows at the bases of trees and hedges. Prussian blue and sap green are bright and better suited to trees. For trees that are closer to the foreground, add some texture to replicate leaves.

For mown grass, apply water to the grass in the foreground before adding texture in the foreground with short, angled pencil strokes—as if you were doing the detail on fur.

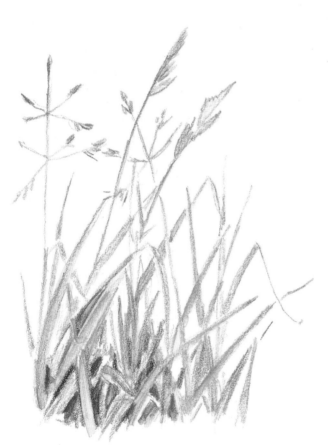

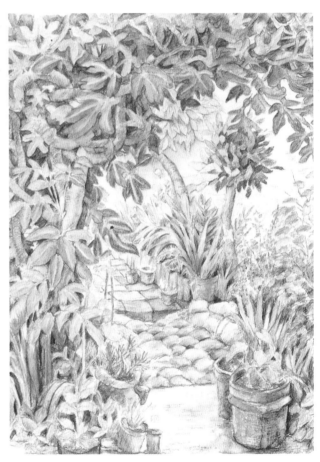

When working in extreme close ups, look carefully to see how the grasses bend. Grass splays out from central roots in particular areas. Nothing will be uniform at this range—the blades will cross over each other constantly. Look closely to see what is happening with the shadows at the bottom. Use a range of greens—as well as sepia, indigo, and purple—to give a sense of the depth at the base of the grass.

This picture of a garden is quite busy, so the greens of the plants somehow need to be differentiated from each other. Suggest the background with straw yellow and smalt blue, and use some flesh pink to tone down the yellow. Color the cherry tree in light green, and shade the bay tree in dark blue so that they contrast with the bright greens of the fig tree. Add the shadows in the foreground with warm browns and purples. Color the pot on the left in turquoise and add detail to the path to create a focal point.

My greens look artificial. How do I make them look more natural? **83**

Do you have any tips for painting different skies and clouds?

With watercolor pencils, you are confined to using single strokes of the pencils, rather than the great washes of color that are the delight of the watercolor painter seeking to capture the perfect sky. Watercolor pencils offer an impressive range of blues, browns, and purples, along with some interesting grays, and these are all very useful in drawing skies. Wetting enables you to gain that feeling of heavy fluidity so typical of painted skies, and it is possible to add further detail using dry pencils.

PAINTING SKY

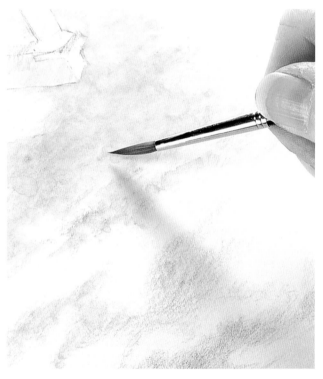

1 When coloring blue sky, use delicate, circular pencil strokes. Do not apply water, particularly if you intend to run the blue into an almost yellow color on the horizon. You will find it helpful to turn your picture upside down and work upward. Make your blues darker as you get higher into the sky, ranging the colors from light or mid-blue to turquoise blue.

2 If you want to wet your sky, do so with the picture upside down so that liquid doesn't end up on your picture. First mark where you want your clouds to go. Clouds are often curved on top and flatter underneath. Make your clouds look as if they are receding by making them smaller and putting them closer to the horizon in the distance. Also draw in any patchy bits of cloud that stream away.

3 As with water, there is no area of a cloud that ends in a definite straight line—everything fades away. Dab, rather than brush, water on and try to avoid hard lines. Work lightly over the top again with pencil to cover over any hard lines left by the watering.

DIFFERENT KINDS OF SKIES

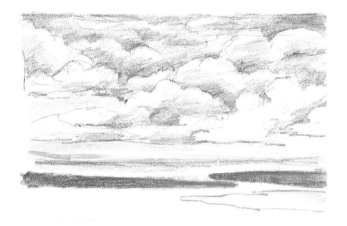

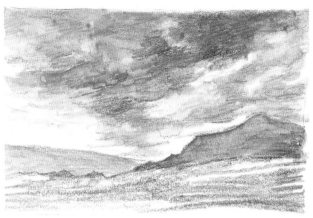

Clouds generally have darker undersides and seem heavier underneath. As with drawing white objects, you should use a variety of colors. Add water to your clouds carefully, or you could get some very vivid results. Apply light violet, blue-violet lake, and blue-gray to darker areas, and use flesh pink and cream for the lighter areas.

Stormy skies show very intense grays and purples. Add depth to your storm clouds with deep violet, indigo, and burnt carmine. As you work, check whether the horizon is very dark or whether it lightens a little on the sky line.

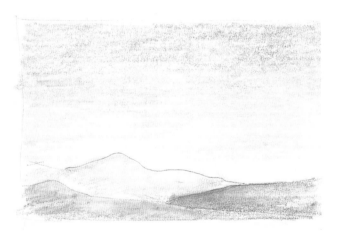

With blue skies, the blue becomes pinkish or yellowish toward the horizon. Work upside down to capture this effectively. Start with pale pink and yellow on the horizon. Then, for the blue sky, use sky blue, turquoise blue, and light blue, darkening the color as you get higher into the sky.

Clouds come in many shapes and forms. Make small studies of clouds, noting shape and color—even the whitest clouds contain some color. If you have no time to draw, keep a pocket camera handy so that you can work on studies later.

How do I get a feeling of distance in my paintings?

In the distance, objects and details grow smaller and also less distinct. There is less contrast in tones, and the colors become muted. Certain colors—reds, browns, and greens—tend to fade from view in the distance, while the ochres and bluish purples maintain their tone, although with less impact. Weather conditions also affect changes in color.

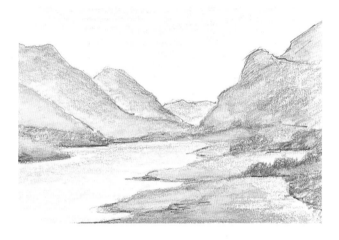

A hazy day will make colors in the distance appear cool and blue, whereas colors in the foreground will seem much warmer. Apply a bluish mauve to the hills in the background, keeping details to a minimum. Color the foreground with warm yellows and greens, and add greater detail to give a sense of distance. The lake reflects the blue sky and sunlight, so apply a very pale blue.

An overcast day shifts the color balance from pale blue to heavy purple. Yellows become muted, whereas greens maintain more of their color in the middle distance. Color the hills in the background with dark purple, varying the tone to create light and shade. Apply a dark green to the shoreline. Make the colors more pronounced in the foreground to give the impression of distance.

Objects in the foreground display a full range of color—in this case, red, yellow, and bright blue. Colors in the distance are muted, such as ochres and mauves. Work your figures up to the same level of detail as the rest of the picture. Think in terms of blocks and shapes, and just try to create the basic shapes of movement and activity.

Detail in a picture should always have a purpose. Look for the connections between items in a scene, and focus on basic patterns and shapes, rather than details. With figures, make sure that you keep the heads in proportion—the head of an adult is about one-seventh the total height. Note that here the level of detail of the figures is similar to that of the nearby trees.

I find it hard to draw different outdoor light conditions. Do you have any advice?

Changing light will affect the colors and shadows of subjects in a landscape. In this series of bridges, you can see how different weather conditions and different times of day can affect the lighting in a scene and how to capture these different light effects.

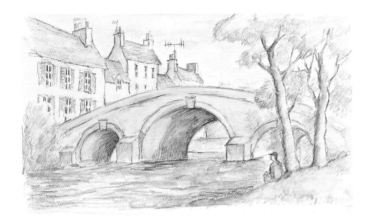

Capture early morning sunlight with a warm yellow wash across the bridge. The light comes from the right-hand side of the picture, so apply strong shadows to the left-hand sides of the tree trunks. However, because of the diagonal angle of the light across the scene, you do not need to apply heavy shadows to other areas of the picture, like the chimneys. There is not much strong shadow on the leaves, and the water reflects the color of the bridge and the sky. The buildings are in strong sunlight, so leave them white.

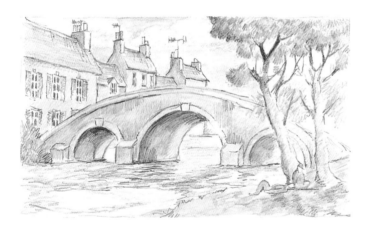

Midday sun casts shadows downward, leaving the bridge in a certain degree of shadow. Darken the warm yellows with shadow colors. The sun is shining from the other side of the bridge, so shade the area inside the bridge quite darkly, particularly the underside of the arch. The faces of the buildings have less glare, no longer in such strong shadow, and the chimneys cast shadows backward. The water reflects an afterglow, while the bridge casts a very definite shadow of its own on the water. Draw the trees dark against the bright blue sky, making those against the skyline very dark.

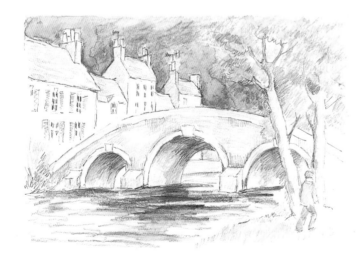

A strong, dark sky has dramatic effects on the light in a scene. Create a stormy feeling with mauves and grays. There is a warm glow from the sun shining behind the clouds. The sides of the trees and most other things in the picture, apart from areas of strong shadow, are lighter than the color of the sky behind. Shade the trees with a mix of blue-greens and bright greens. This will give them a yellow tinge that stands out dramatically against the stormy sky. Use Naples yellow on the houses to capture the light. Color the river darkly so that it reflects the sky.

Demonstration: Basic Landscape

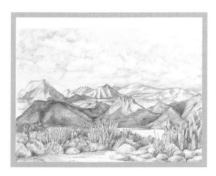

The original photograph shows a well-demarcated landscape of hills and mountains, with foreground cacti and a moderately cloudy sky overhead. The chief interest in the picture is the contrast between the sunlit sides of the mountains and the shadow, which offers an almost lunar landscape, along with the cacti in the foreground.

1 First work very carefully to plan the outlines of the mountains. Then clearly delineate areas of sun and shadow. Add the areas of cacti in the foreground, and work out the approximate areas of blue sky and the shapes of the clouds.

2 Draw the clouds and sky in a warm neutral tint of flesh pink. Shade the undersides of the clouds in light mauve and blue-violet lake. Add the blue sky using sky blue and light blue, with a touch of turquoise.

3 When satisfied with the initial look and style of the sky, color the sunlit slopes in light ochres. Apply the color more densely as you approach the foreground.

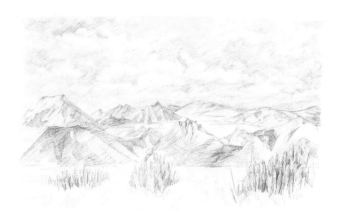

4 Paint in the shadows of the hills in smalt blue, mauve, and blue-violet lake. As you come toward the foreground, use some Delft blue and deep violet. Rough in the cacti to create a contrasting set of bright yellows and greens in the foreground.

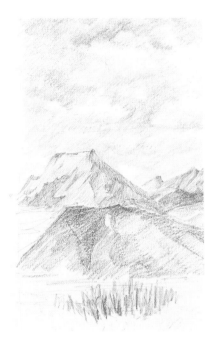

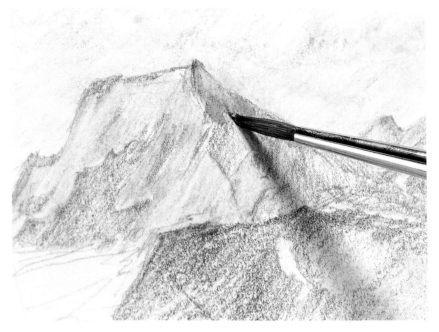

5 See how the color deepens toward the foreground. Work precisely to draw the effect of light and shadow on hills. The distant mountain has a unique shape. Copy this carefully to give a realistic feel to its shadowed slopes.

6 Wet the base colors to make the picture more solid. The colors will also become more vibrant. Take care to wet each small area separately to maintain the contrasts between different areas.

7 When you have carefully watered the whole picture, reassess the color balance. If the foreground hills are too purple, lift some off with a wet brush and tissue, and add some of the other colors. If the sky is too faint, go over it again.

8 The background hills recede effectively, but the mid-ground mountains need strengthening, and the clouds need more detail. Add more weight to the clouds with more dark tones and detail to the shaping. Give the middle ground hills further coats of brown ochre and even some burnt carmine to tone down the purple edge and to bring them closer to the foreground.

9 Suggest the immediate foreground by adding rocks, which will give the whole picture a greater level of depth. The boulders echo the colors of the mountains and create a greater sense of harmony, showing how gradual coloring helps bring the compostion into its own right.

10 Another reassessment reveals that two areas of the mountains in the middle ground appear to be darker than the rest. Lighten these, first using plastic laminate and then a wet brush and tissue.

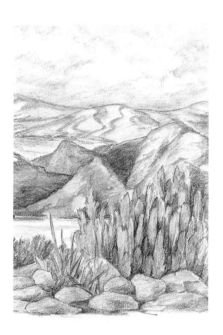

11 Add the lighter colors over the top of the area once it is dry. Steepen the slope of the valley on the right-hand side very slightly to create a more three-dimensional effect.

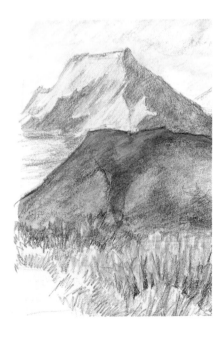

12 Darken the other middle ground areas slightly to achieve a more effective tonal balance.

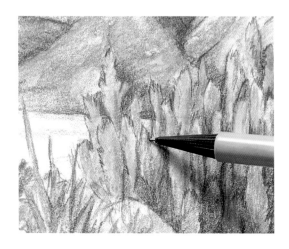

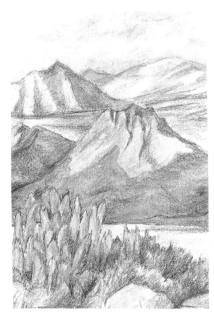

14 This detail really shows how color recession works. Up close, you can see greens and yellows, shadowed by sharp contrasts of deep indigo. These are colors that appear only in the foreground, emphasizing the proximity of the cacti. In the middle ground, the mountains are shown in solid ochres, with deep but warm shadows, while in the distance, these fade to paler colors and indistinct blues.

13 Shade the foreground cacti on one side, observing the light source. Then use graphite pencil to sharpen the contrast of both the cacti and the ridges on some of the middle-ground mountains.

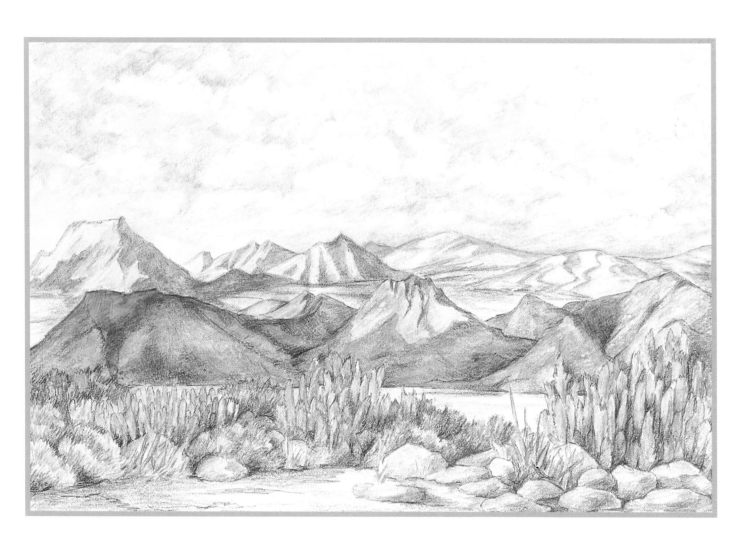

15 Note that the composition leads the eye from the foreground boulders and cacti toward the lake. The detail of the mountains carries you out and away into the distance, while the clouds offer additional interest to complete the picture.

Demonstration: Basic landscape **91**

5
Capturing buildings and townscapes

In much of art, there are no hard and fast rules, but with perspective there *are* rules, and these are worth knowing, as mistakes in perspective do tend to leap out at the viewer. These rules are not very difficult to grasp, although it is helpful to sort out the terms involved at the outset. Instead of *horizon* and *skyline*, which are often used inaccurately and confusingly, this chapter uses *eye line* to avoid confusion. This is the line on which receding parallel lines converge on a level with the viewer's eyes. All perspective relates to this eye line. It is on this line that all receding lines in a scene disappear—in other words, where they have their vanishing points.

The demonstration, a Greek townscape with a church, is an introduction to basic perspective. There is one vanishing point near the center of the picture, making it an example of one-point perspective. In addition, there are no figures to complicate the scene, making it an excellent starting point for coming to grips with perspective. The key is to get the angles right at the initial stage of the graphite drawing, when mistakes are easily rectified.

There are many decisions to be made in arriving at an interesting composition. Here you will find advice on choosing a viewpoint and framing your picture in such a way that the focal point encourages the viewer's eye to move around the picture. If working from a photograph, you will find helpful advice on how to find the eye line in a photograph. Often, there will be no useful horizon on which to situate a vanishing point, and where the sky is visible may not be the skyline. The eye line is different, depending on wheher you are standing or sitting, so take care if you begin a painting standing up but complete it sitting down.

Perspective is not at all difficult to master, and it is well worth the effort. For drawing buildings, it is essential.

How do I plan an interesting composition?

Decide where you want the main emphasis of your picture to be. Do you want the viewer's eyes to focus on the center or to travel round the picture? You could place the main focus high up in the picture or down low.

One traditional method is to place the focus on the *golden mean*. This is found by dividing the picture both horizontally and vertically into thirds. This *rule of thirds* gives four possible points of emphasis at the points where the lines intersect. Placing the main focal point of your picture on one of these intersections—the golden mean—invites the viewer's eyes to travel around the picture. This gives a range of interest and minor foci within the picture, nearly always making a more interesting composition than when the main emphasis is placed right in the middle of the picture.

Before you start your main drawing, do some small rough drawings to explore what you might do with your picture. You could alter some of the details in the scene to create a more dramatic picture. In this picture, two rough sketches of the same scene show the effects that can be achieved with different compositions.

In this rough drawing, the lines of movement—the sweep of the drive and the skyline against the hills—draw the eye toward the focal point of the picture, which is the house. The house lies on the golden mean, on the lower left-hand point of intersection. The gate compels the eye to stop before reaching the edge of the paper and contains the image within the borders.

Right In this color rough, the scene has been altered. The road runs toward the right in a straight line, and the gate has been removed. This directs the eye down and to the right and stretches the distance between the house and the tree on the right. The line of the path does not invite the reader toward the house.

Below Here the house is placed in the center, viewed from the front. This creates a very simple, static composition with the eye focused on the middle of the picture. The surroundings have become secondary to the house itself.

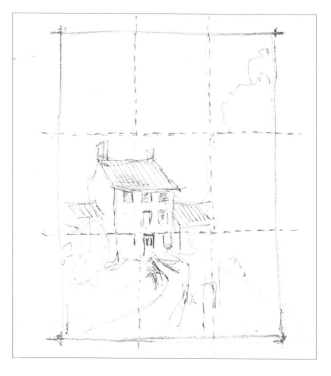

Right Here the house is viewed from an angle that directs the eye beyond it, evoking a sense of dynamism and expectation, as if the viewer is expecting someone to walk around the corner.

How do I "measure" a scene to get the perspective and proportion of my buildings correct?

An awareness of the principles of perspective helps you to draw what you see with greater accuracy. Very simply, perspective is the illusion that things become smaller the farther away they are situated. Work out where the eye level is—this is the line that would be created if you gazed straight ahead horizontally, without tilting your head up or down. When you look for the "horizon," this is not actually the skyline but the horizontal line you would see in the distance that is level to your point of view; for example, approximately where the distant sea meets the sky.

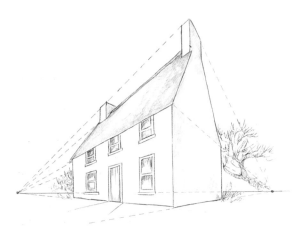

This house was drawn with the eye line just above ground level, so it appears elevated, as though the viewer were positioned slightly downhill. Notice that horizontal surfaces, such as the windowsills, the roof, and the top of the door frame, all converge at the vanishing point.

This house was drawn with the horizon at eye level, and it appears as though the viewer were standing on the same level as the house. The vanishing point converges with the eye line farther away when the house is observed from this point of view.

Below Perception of perspective is guided by the position of the vanishing points on the same eye line. Buildings, when viewed at different angles will have different vanishing points, but all will be situated on the same eye line.

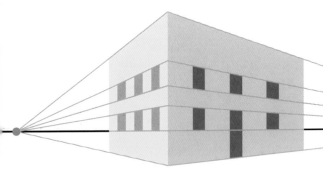
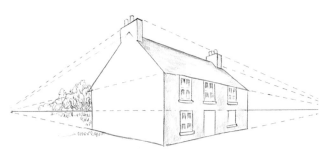

This sketch of a Greek temple ruin provides an example of two-point perspective, with lines receding into the distance in two directions. The vanishing points are the points on the eye line where the lines converge. Normally, as in this case, these are well off the page, but an awareness of them is always of great assistance to the artist.

ARTIST'S NOTE

If you are on a hill, looking down on a subject, the horizon will be higher and the parallels will slope up toward it. If you are sitting directly beneath a tall building, they will slope sharply down toward a low horizon. It is vital to remember this when painting on site, because if you alter your position, for example, by sitting down after you began the painting standing at an easel, the perspective will change, and this can be disconcerting.

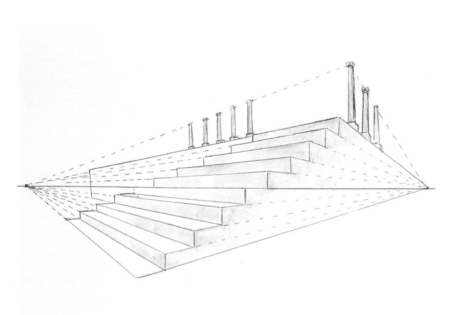

The vanishing points are visible in this sketch of steps and pillars. The steps above the eye line run down toward it, while those below run upward. With two-point perspective, vanishing points are often beyond the perimeter of the page. The location of these points depends on the angle of the object in relation to you. One aspect of a building may vanish at the eye line, within the frame of the picture, while the other extends way beyond. This is because you can have a vanishing point at any point on the eye line.

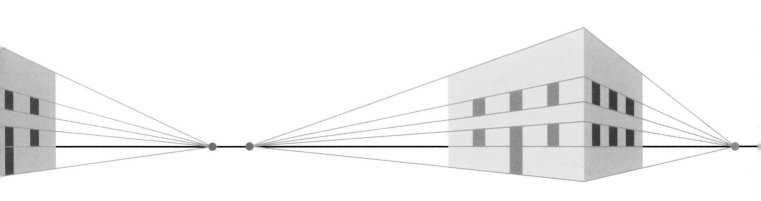

How do I "measure" a scene to get the perspective and proportion of my buildings correct?

How do I find the eye line in a photograph?

When you are sketching from life, it is easy to establish the eye line because it is on a level with your own eyes. However, if you are drawing a scene from a photograph, it is harder to determine the eye line because the photograph may not include a sea horizon, or the skyline may not be the horizon—it may be above the rooftops, for example. When there are no buildings in a picture, the proportions of different elements are unlikely to be a problem. However, where there are buildings, the perspective must be accurate, and knowing how to find the eye line helps to avoid the kind of mistakes that are very easily made.

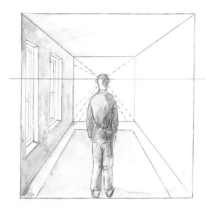

The lines of the ceiling, rug, and windowsills converge at the vanishing point, which is always situated on the eye line.

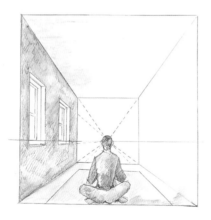

If you sit down on the floor, your eye level is lower and you see less of the floor. The rug is foreshortened, and you see more of the ceiling. Again, the parallel lines created by the windows, ceiling, and rug all converge on the eye line.

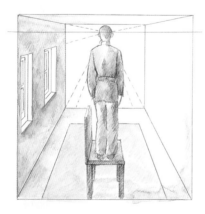

If you stand on a chair, your eye-level is raised, and you see more of the floor. Once again, note that everything that is square-on to the viewer and parallel to the walls vanishes to the same point on the eye line.

Above In this street scene, follow the lines of the roof edges on either side of the street down toward the middle, and they will meet at the point where the eye line runs across the page—level to the photographer's eyes. Notice that all the other lines created by the edges of the windows will meet at this same point.

Above *Lucca from Torre Guinigi* by Ray Evans illustrates the enduring fascination in the pattern of interlocking planes—in this case, the slanted roofs and walls of a townscape. The high viewpoint here provides an overview of the structural logic of the scene.

Demonstration: Greek church and townscape

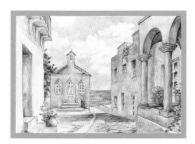

This Greek townscape is a straightforward introduction to perspective and dimension within a composition. It has a single vanishing point on the horizon, behind the church door; there are no figures to complicate the scene; and it is composed mainly of straight lines. Begin by sketching in guidelines with a graphite pencil, tracing the lines of the street, the walls, the windows, and the arches as they recede. Erase and redraw lines as often as necessary in the early stages, as it is much easier to make corrections (by erasing graphite pencil marks) before any color is added.

1 The focal point is the church door, which is not dead center but a bit to the left and slightly below the middle, on the golden mean. Draw in rough guidelines to follow the lines of the street, any windows, arches, and so on—use a graphite pencil because this will be easier to erase. It is very important to get your angles right at this stage. As you become sure that your lines are in the right place, darken them to indicate the final line.

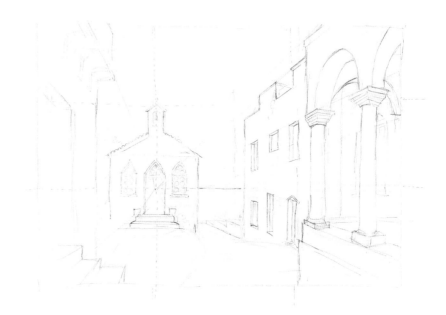

2 Erase guidelines and any other lines or marks that you no longer need before applying the overall ground color. Squint at the picture so that it is slightly out of focus and you are not distracted by detail. Block in the basic tonal areas of the picture, distinguishing between the areas of shadow—cast by the building on the right, in the doorway, and under the arches—and the areas of light. Also set down basic areas of color for the sea, the sky, and the building.

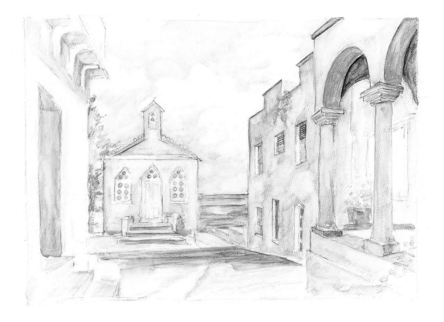

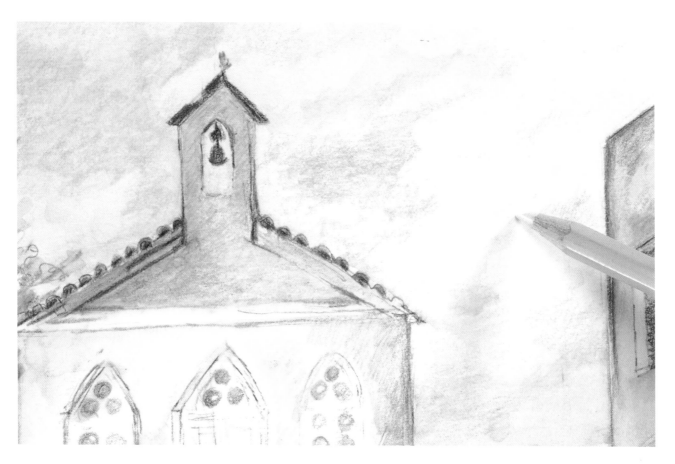

3 A wash often dries unevenly where there are large areas of color, such as the sky. Lightly work dry pencil over the top to soften any lines left by the water. Make small, circular marks and work much more evenly than you would when applying an overall ground color, because you will not be wetting that area again. If you have pressed too hard, leaving grooves in the paper, don't be too concerned about this, as it is unlikely to be noticeable to anyone else.

4 Use the same colors that you began with on top of the wash. If the wash hasn't achieved the effect you had hoped for, you can usually change the color—a very useful quality of watercolor pencils. Here the color of the church is being changed from a brownish color to a purplish one. You will have to press a bit harder once the paper has been wet, but you will find it much easier to create areas of flat color.

5 The sea changes color closer to you, in this case becoming more purple and turquoise. Use fairly long lines to hide a slightly patchy wash. Make your lines shorter and wider to achieve a ripple effect on the surface of the sea closest to the shore. Run your lines right up to the edge of the area you are coloring—in this case, the side of the church.

6 Add interest to a very blank wall with detail like extra foliage. Use bottle green and mineral green to introduce a brighter feel to the picture. These colors make greens look more natural and have a calming effect when used over yellows. Always use a variety of colors, and never think of what you are doing as simply coloring in—colors are never plain, flat hues. Note the contrast between the windows and the wall, as well as the darkness under the windowsills and the tops of the window frames.

7 Even shadows contains colors, so look for these and use two or three when drawing them. Define details with either a dry or a wet pencil—a pencil with a wet point will give a stronger color, but use this only for final lines and details. Use pencil lines to add extra texture to objects in the foreground. For example, strengthen the shadowed side of the column with burnt carmine.

8 Leaves and other vegetation look very dark against the sky, so reproduce this darkness by using the full range of greens, particularly olives and dark greens. Press harder for stronger color and impact.

9 More detail and texture is visible in the foreground, so show this in your picture. Use the tip of a wet brush to pick out details in the paving of the street—a single brush stroke onto the lightly penciled purple in the wash. Wet any areas that you would like to make more solid. The slightly elevated surface of the paving casts a slight shadow into the hollows between the cobbles—show this to give added texture.

10 Sharpen up the final foreground details, particularly along the edges. Deepen the shadows under the arches and on the pillars with a mix of blue and carmine, remembering that the edge of a dark area against a light area looks darker. Pay attention to light and shadow on the individual windowpanes, particularly because these are foreground details.

11 Hold your picture up to a mirror to check the final color balance. Give the church doors emphasis by adding light blue to draw attention to this focal point. There is a small shadow on the road in the central foreground, which shows how light is shining through from the right, beyond the arches, onto the building on the left. Noticing and drawing this helps to explain the areas of light and shadow in the picture.

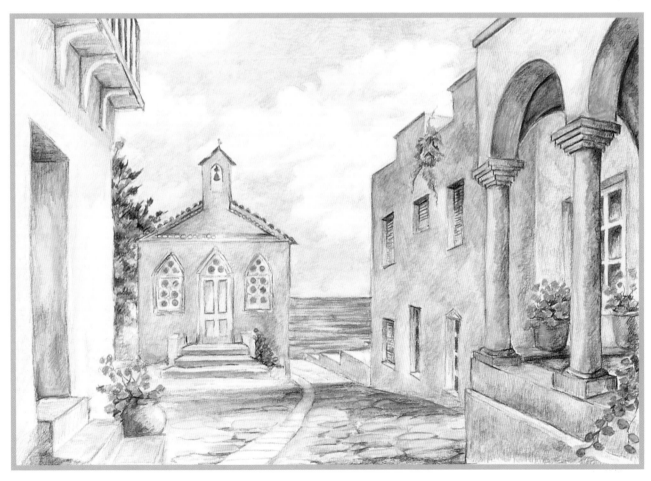

6
Drawing waterscapes

Water provides an artist with many wonderful challenges. It offers movement, reflections, and changes in color and light. This chapter contains information and advice on how to see, draw, and paint many different forms of water, from crashing waves to the calm surface of a sheltered harbor.

One rule applies to all bodies of water—water is rarely stationary. Unless the water surface is absolutely static, few lines or forms in water will end suddenly, but instead will taper away. The colors in the water are dependent on what it is reflecting, whether this is an overall effect, such as the sky, or a specific area of color, such as the reflection of trees or reeds. Another rule to remember is that reflected colors will be muted versions of the original.

Watercolor pencils are particularly useful for painting water because they combine the dual effects of the watercolor wash and the precision of drawing. These can create striking visual contrasts in line and form, particularly between the fluidity of the water and the solidity of surrounding objects and structures. This can be doubly effective when capturing an object and its reflection. As a general rule, an object that stands vertically to the water will have a vertical reflection. An object that stands at an angle to the water will cast a vertical reflection, but this will be a mirror image and the reflection will be angle in the same direction as the object—a common mistake for beginners is to continue an angled line straight into the water. Reflected lines also may be appreciably longer than the objects themselves.

Depending on how choppy the water is, the reflection will be correspondingly fragmented; on a very still day, the reflection will be barely disturbed—the water acting like a mirror—but, in rough water, a reflection can be disturbed to the point of abstract colors and shapes. Always look as closely at the reflection as you look at the solid objects in the composition. The reflections are an integral part of the painting.

Whether you work from photographs or from life, sometimes you may need to crop or reorder the scene you are painting to make the most of the composition, to add a focal point, or to improve the color balance. However, don't underestimate the visual interest and impact that water has. A waterscape does not always need a boat or a child to give it impact. Even if the ocean takes up four-fifths of your painting, it can still be visually dramatic and beautiful.

My reflections in water always look too solid. How can I improve them?

The surface of a body of water affects the way reflections appear. Similarly, the lines of the reflections can be used to describe the atmosphere of the painting, whether stormy or calm. If the surface is very still, the reflected lines will be smooth and scarcely broken at all. If the surface is quite rough, the reflection will be much more fragmented. Reflections in water are a mirror image of what is above—if the object leans one way, its reflection will lean in the opposite direction.

1 Draw an initial sketch. Observe the reflection just as carefully as the objects that make them—don't simply make the reflection an upside-down replica of what you see above the water. Some reflected lines are a lot longer than their originals, and the colors are more muted. When you sketch your composition, allow adequate space for the reflection, which may take up to two-thirds or more of the finished painting.

2 Apply ground color very sparingly when dealing with a light-colored sky and its similarly light-colored reflection. For the sky, very lightly apply a combination of sky blue, smalt blue, and silver gray. Treat the sea the same way because much of its color is a reflection of the sky. On a very still, gray day, reflections will be very clear and undistorted.

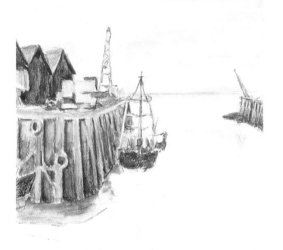

3 The colors in the sea are slightly warmer than in the sky. Erase any small guidelines at this stage, unless they run into very dark-colored areas. Run the sky up to the edge of the buildings and other objects. The sea often has a slightly green hue, becoming very light in places. Run an overlay of blue-gray over most of it but not over the reflection of the boat. Where the sea darkens in the foreground, add a little bronze—almost any other color will be too warm and yellow. Add a tiny bit of fairly dull green, such as cedar green. Add water to the pencil marks to enhance the dull green. Add water to the sky too, brushing in smooth strokes from one side to the other to capture its flat color (you may find it easier to turn the picture upside down to do this). Don't worry about slight run-back marks—you can pencil over these later.

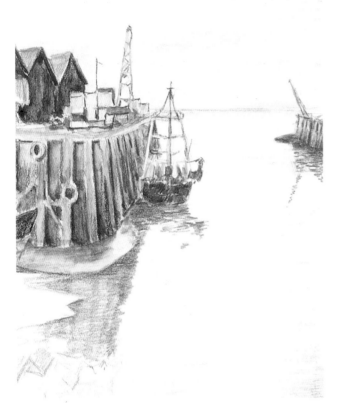

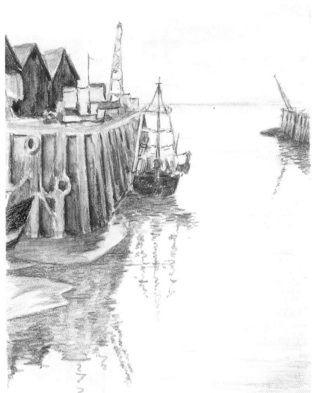

4 Use extremely sharp pencils when you are working on a very small scale. Look for the light and dark in the area above the water, and try to capture fine detail. Use a variety of different browns from the blue/green end of the brown range—sepia and burnt umber, rather than chocolate and burnt carmine. Objects below the tidemark will be browner and darker where they have been saturated. Draw the rigging on the boat with very light strokes. Paint the background around the rigging first, if you are not using masking fluid.

5 Paint the reflected image. Avoid hard edges by drawing the brush from the white edge inward. Wash the brush each time between strokes. On the defined outer edge, brush from the color outward. The color below the water is more brown and green—duller, without the same intensity of the original.

ARTIST'S NOTE

Drawing reflections demands careful observation. Don't make assumptions and draw what you *think* should be there. Avoid thinking of what you are drawing in terms of the subject and its reflection. Rather, look for areas of dark and areas of light, whether they are above the water or reflected on the surface of the water. By close observation, the ways in which different kinds of water modify the colors and forms of what they are reflecting will become apparent. With very choppy water, although it will not be possible to capture every detail of the fragmented reflection, close observation will reward you with a more accurate impression.

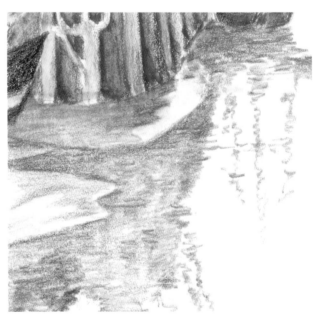

6 Note that the reflected image fractures at the edges. Where this contrasts with the reflected sky, the lines are quite sharp and dark, though the body of the reflection is lighter than the quay and boat.

My reflections in water always look too solid. How can I improve them? **107**

Q&A How do I paint moving water?

A subject full of life and energy, moving water is one of the most fascinating challenges facing an artist. It reflects light but is also translucent. The colors and shapes change with the light and movement, and the reflections are infused with a wide variety of blues, greens, and browns. The trick is to capture the range of color and form without making the water appear solid and immobile. Varying the strokes used for solid objects to those for the water is one useful technique.

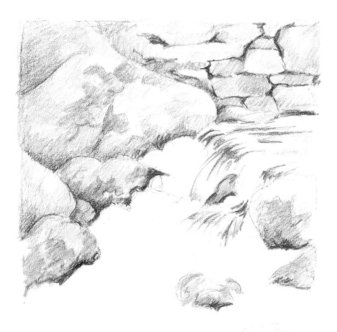

ARTIST'S NOTE

Water always runs in smooth curves, so never finish a stroke with an abrupt end. In the distance, you cannot see these curves easily because they are telescoped into a series of broken horizontal lines, but on the surface closer to you, you can see the movement of broken curves and swirls. Water that is deepest, or farthest away from the breaking foam, swirls in longer, more gradual curves. The colors may be more uniform because the reflections are not as detailed as those in water near to you. When the water is nearer to you, the colors reflected include muted greens, browns, and ochres reflected by trees, or even the browns and ochres of the river bed or rocks beneath the water.

1 Fast-running water is generally composed of three major components: the static rocks or riverbank, the water itself, and the foamy air bubbles caused by the cascade. To capture these, first sketch in the rocks. These are the static structure for the painting and create the skeleton for the piece.

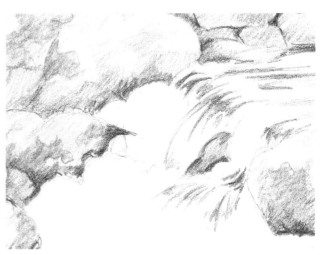

2 Flowing water follows the general principles for painting all bodies of water; there are no short, stippled strokes, and all strokes go in the direction of the flow. Water generally flows smoothly over rocks, causing glinting highlights. Moving water always has areas and shadows that are very dark, where the movement of the water makes peaks and troughs that overshadow each other.

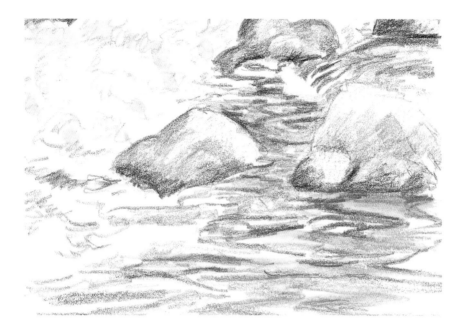

3 The water below a waterfall is choppy, moving in irregular swirls around the rocks and becoming more broken as it approaches the foam. Where it is choppy, there are more facets that reflect the light, so the lines and areas forming the water need to be shorter, sometimes even slightly peaked. The color will often appear darker, more like indigo, contrasting with the reflected lightness of the sky.

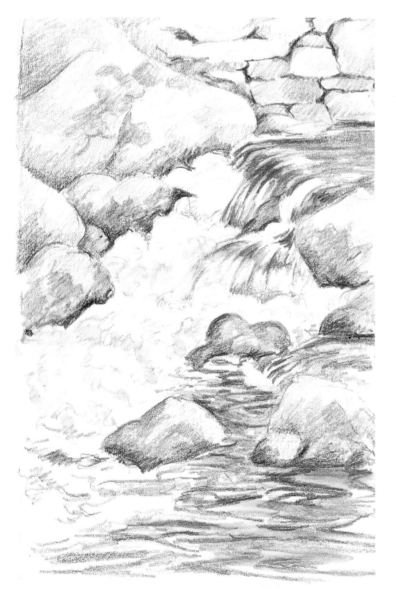

4 This sketch of a waterfall shows three entirely different treatments of water. At the head of the waterfall the lines are smooth and almost horizontal, with gently curving, controlled lines hinting at the smooth fall of the water over the upper rocks. At the bottom of the waterfall, the water swirls toward the viewer; notice that the lines are more spread out, almost zig-zagging toward the front.

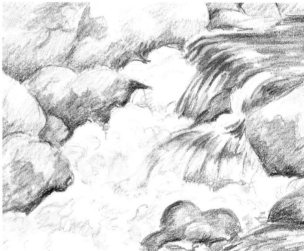

5 Where the water turns to foam, use a sharp delineation to create a clear distinction between the white foam and the background water.

What tips can you give me for capturing breaking surf?

Breaking surf is often seen on a dark background—rocks or the sea—against which it stands out brilliantly white. To create this effect, masking fluid is tremendously useful because it captures the small flecks of spray very effectively, something you would struggle to do using any other technique. However, masking fluid has its drawbacks—it can ruin brushes, clog paper, and leave stark, white holes in your drawing. Take time to practice the effects you can achieve with different applications of the fluid.

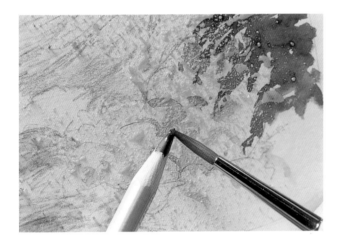

1 Draw the initial sketch, keeping the area for the surf in your picture white. Use an old toothbrush to create the delicate bubbles and spots of foam. Flick your thumb along the loaded brush to produce a shower of droplets of masking fluid, to show the spray of the wave against the rocks. Then let the fluid to dry.

2 Do not try to work on wet masking fluid, as it will ruin both the effect and your brush. Once the fluid has dried, rub off any spray that is in the wrong place. Use a pencil to lay down color in areas that have little or no masking fluid. The pencil will snag on the spots of dry masking fluid and leave too much color around them.

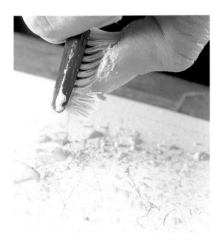

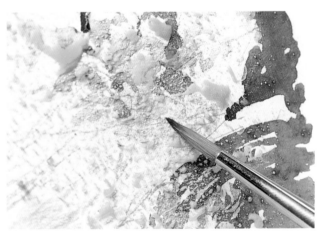

3 Take the color from the pencil lead with a brush, and paint the rocks and wave patterns around the masking fluid, using dark grays, browns, and indigos for the rocks. For the sea, use blue gray, indigo and the viridian greens (add a little cedar green to prevent the viridian from making the sea look unrealistic).

4 Where there is no masking fluid, apply some lines with a brush to illustrate the movement of the breaking wave.

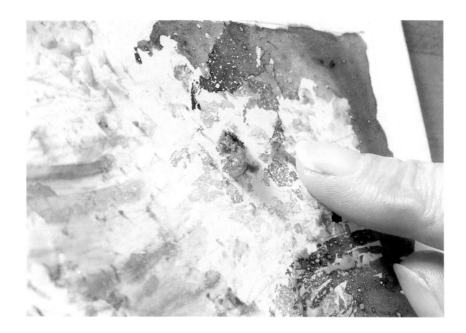

5 Once you are satisfied with the effect, rub off the masking fluid to reveal glittering droplets of foam on the rocks. If any further touches are needed to the breakers, apply them now.

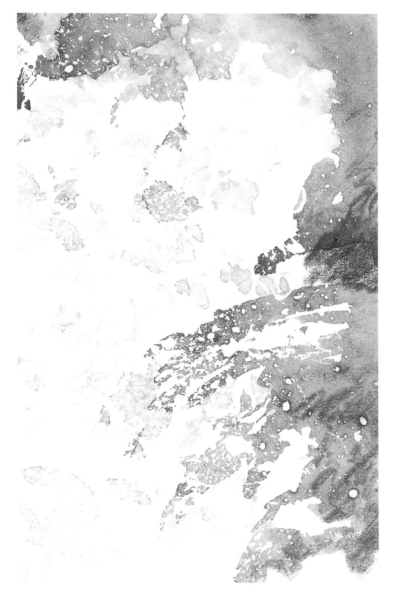

6 Masking fluid is very effective for capturing the visual effect of surf and spray, as well as for creating a strong contrast between white foam and the surrounding sea and rocks.

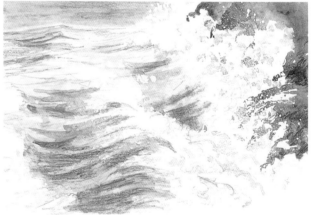

7 The white of the paper stands out against the dark rocks, capturing the feeling of spray in a way that would be difficult to achieve by any other means.

What tips can you give me for capturing breaking surf?

Demonstration: **Figures in a seascape**

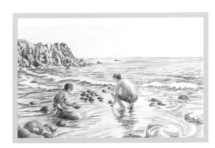

Working from a photograph makes it possible to alter details so that elements and colors can be brought into a more satisfactory relationship with each other—in this case, a predominantly blue, wintry scene has been made much warmer with the yellows of the sand and the flesh tints. This seascape offers the artist many challenges: figures, moving water, rocks, and reflections. The challenge is to create a unified painting while keeping the elements distinct from one another.

1 Photographs contain an enormous amount of detail, and often it is necessary to simplify in order to produce a more cohesive painting. In this photograph of two children on a beach, although the colors are lovely, they are overwhelmingly blue. The figures are distant from each other, and the rocky coastline overwhelms the image.

2 Sketch your drawing. Reduce the distance between the figures. Sketch the outlines simply and avoid drawing too much detail. Include some details, such as the shadowed soles of the feet, because these stand out in silhouette against the pale sand and will be integral to the painting.

3 Mark the lines of the breaking waves with masking fluid. This is the ideal medium for such work. It doesn't matter that the line is not well controlled because water, by nature, flows in irregular patterns. Apply the masking fluid with a rubber-tipped color shaper, and let dry. Be careful not to get any masking fluid on your brush.

4 Turn the paper 90° to draw the line
of the horizon. Pull the line
downward toward you in a set of
"backstitch" strokes, so that it will be
relatively straight and even. Don't use a
ruler to draw the horizon, it will be too
regular and unnatural.

5 Turn the paper again 90° so that it is
upside down, and apply the colors
for the sky. The sky color should be a
graduated tint from flesh pink at the
horizon to pale blue for the upper layers.
Leave the sky as dry pencil to avoid
runbacks. Turn the paper right-side up,
and add faint blue gray, light blue, and
juniper green to the sea in horizontal
strokes.

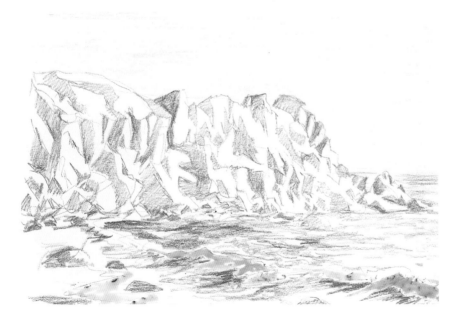

6 The rocky headland is very jagged,
with many highlights and shadows.
Draw the various shapes of the shadows
to produce a series of jagged and abstract
shapes that give interest to the distance.
The dark sea colors beneath pick out the
highlights of the headland. Draw in the
main shapes of the foreground boulders
and their shadows using indigo and
Delft blue.

7 Add water in the colors to give a firm base of color to the sea, the headland, and the foreground. Keep the colors pale, but draw in the basics of the reflected figure and the swirls of water that have formed on the sands with the outgoing tide. Assess the tonal balance of the picture, and add color to keep the overall painting in balance.

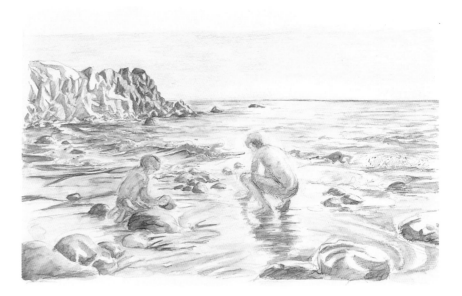

8 Apply a coat of brown ochre to the rocky headland to add solidity. Darken the sea color beneath the rocks with a mixture of indigo and juniper green. Add water to the pencil lines. The color on the underside of the breaking wave is darker than the topside.

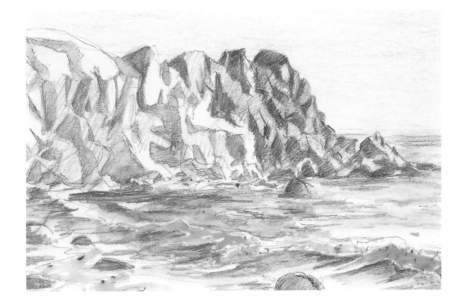

9 Once the colors of the sea have sufficient depth, remove the masking fluid by rubbing it off with your finger. Some masking fluid pulls off easily in long strips but, if not, rub across the narrow width rather than along the length of the strip. This will minimize any damage to the surface of the paper.

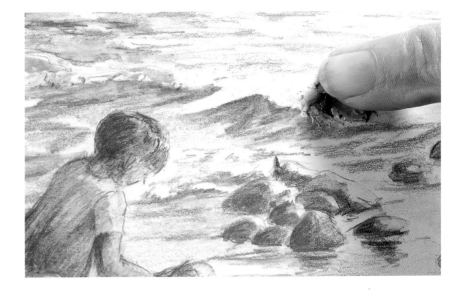

10 If the figures still do not standout boldly enough against the mid-color of the sea, add color to their shadows and dark areas. The picture is developing gradually, but more density of color is needed in the foreground and more intensity and interest in general on the right-hand side of the picture. At the moment, it is weighted both in color and texture to the left-hand side.

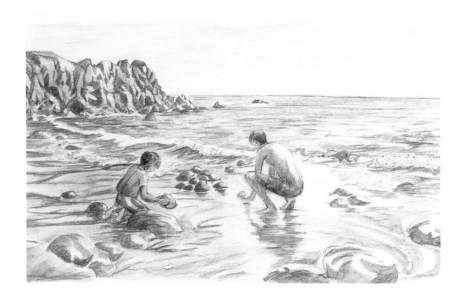

11 Add more color to the lower parts of the headland, to modify the indigo base color. Add chocolate, burnt carmine, and even a little Delft blue to the shadow areas to create further depth. Wet some areas again to strengthen the shadows.

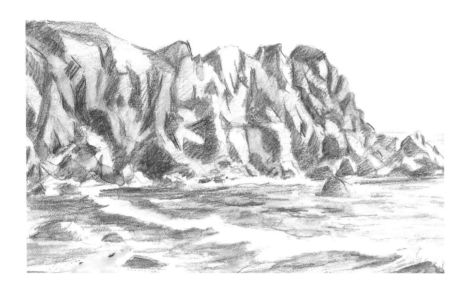

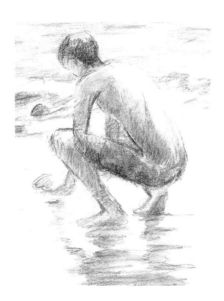

12 The larger figure is near completion—the shadowed areas work to emphasize the physical contours, such as the shape of the back. Run colors right up to the edges of objects. The shadowed sole of the right foot expresses much of the stance of the figure, and the beginnings of the figure's reflection add to the impression of water on the glistening sand. Add some ochre to the sand on the left, and shade reflections in the ebbing water with sky blue to reflect the pale sky. Warm the foreground with heavier ochres, and pick out the warmer colors of the sea.

13 Warm the foreground rocks using a base of indigo, but add chocolate, burnt carmine, Delft blue, and cedar green to give a sense of structure and solidity. Treat the rocks at the edge of the sea in the same way, keeping their glistening highlights, with the light coming from the right. Note that the rocks, as well as the figures, have reflections. Darken and warm the reflection of the central figure with touches of Van Dyke brown and sienna. Add a coating of cedar green to the sea on the right to add a subtle change of color toward the light.

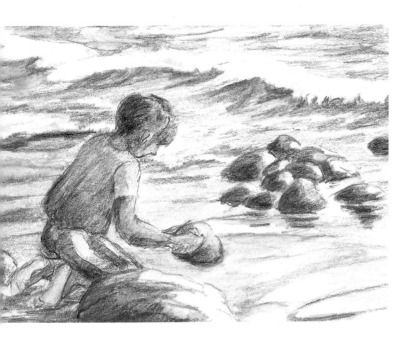

14 Concentrate on the shadows and shapes when painting the smaller figure, rather than trying to draw details. Angles are more important than features, so look closely at the angle of the head, the line of the back, and the shape of the feet. This will help to situate the figure in the scene.

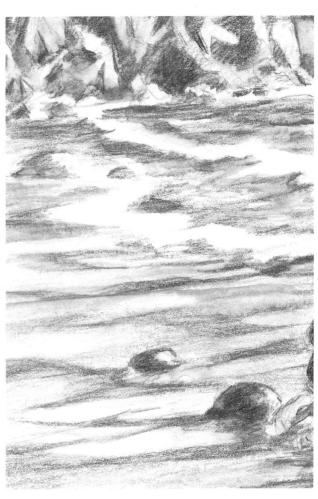

15 Pay attention to all the different lines and shapes involved in this seaside picture. In the foreground, there are the sweeping curves of the ebbing water, along with the round boulders of the beach. In the middle ground are the irregular lines of breaking waves, while the background shows the sharp, straight lines of the angular rocks.

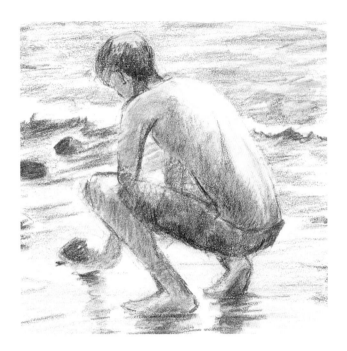

16 Figures in a landscape or seascape should have the same level of detail and color complexity as any other feature in the scene—no more, no less. Express as much as possible of the environment. For example, describe the stance of the figure by the line of the back, and show how this is emphasized on one side by the sea. Use the shadows on the other side of the torso to complete the effect. The back is a focal point; the rest of the body around it—the legs, arms, head, and feet—merely add to the basic impression created by the back, set boldly against the sea. Use the broken reflection to place the figure firmly in context.

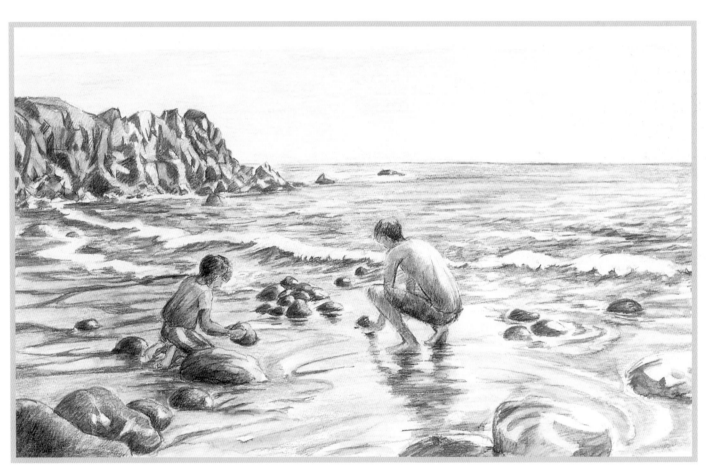

17 This is a very inviting composition. The swirling lines of reflection in the foreground lead straight up to the central figure, which is one third of the way up the picture. The direction in which the figure is facing leads back to the smaller child, who is placed on the golden mean. The lines of waves lead the eye up to the jagged rocks of the headland, and from there out to sea.

7
Portraying people and animals

When drawing people and animals, getting the proportions correct is the key to achieving a likeness. Whether you prefer to work with basic guidelines—dividing a human head, for example, into thirds, with the eyes coming about a third of the way down the head, and the bottom of the nose a further third down—or not, the key to achieving a likeness is to define it very gradually. Build up the longer defining lines in your picture from numerous short lines, beginning with the basic areas of shadow and light to establish the tonal composition.

When capturing skin tones, don't think in terms of an overall color. If you look closely at a face of whatever color, you will see subtle variations in each tiny concave and convex area where the face is shadowed. Don't be tempted to use a color like flesh pink; true flesh tones are built up, as is often true with watercolor pencils, from many different colors, from straw yellow to blue violet lake. With color, as with form, look closely and build slowly.

So much of our attention is focused each day on eyes and mouths, yet they are strangely difficult to draw. This chapter contains many helpful tips on how to capture these defining features. Interestingly, the color of an eye is a very small part of its individuality, the eyelids being much more important in defining a likeness.

Watercolor pencils are ideally suited to drawing hair. Use the pencil points to follow the flow lines of the hair. Always work in curves rather than straight lines. The demonstration portrait puts into practice all the advice above, from how to achieve a likeness to how to accurately recreate skin tone and the appearance of hair.

Animals are even less likely to sit still than human subjects are, but overcome this problem with the help of quick sketches and photographs. The shape and posture of animals is important, so tackle the outline first. The same rule of building slowly applies to achieving a likeness—draw a specific animal always, rather than a generic animal. As with hair, watercolor pencils are ideally suited to creating the effect of fur. Work with short, angled strokes in the direction of the fur to achieve a satisfyingly realistic effect.

The demonstration puts into practice much of the advice about drawing animals, including capturing posture, carefully positioning eyes and ears, and recreating the effect of fur.

My model's skin often looks lifeless in my portraits. How can I draw skin more realistically?

It may seem like a good idea, but don't be tempted to use the color flesh pink for skin. This is a very useful color for clouds, white jugs, and many other things, but it isn't good for skin. If you cover a face with this color, it will blind you to all the face's shadows and nuances. Instead of beginning with flesh pink—or any other overall color—first block in the main tonal areas of the face without worrying about detail. This will help you to study a face correctly from the start and to build up gradually to a well observed and detailed picture. Don't be afraid to use colors that may seem like strange choices: blue violet lake, light mauve, red violet lake, straw yellow, brown ochre, burnt sienna, terracotta and pale vermilion. By layering these colors and paying attention to the many tiny areas of shadow on a face, you can create very realistic skin tones.

1 Observe your model closely, and start blocking in the many small areas of shadow you find on the face, using mauves and blues.

2 Start with an undercoat of light, creamy yellow, like straw yellow. On the shadowed side of the face, use darker yellow ochre. Calm both of these colors with raw sienna, which is brownish yellow with pink overtones. Use burnt sienna over this.

3 During the initial stages, pencil quite lightly, as you don't want too much color on the page before you wet the drawing.

4 Choose an orange-red, like pale vermilion, to start building skin tones on top of the wash. Include some color on the cheeks, but keep it all very faint at this stage

5 Leave detailed work on the eyes until later. Add some dark browns, purples, and indigos—including some burnt carmine—toward the end.

ARTIST'S NOTE

There is no fixed "recipe" for any kind of skin color. When drawing different colored skins, look for the colors you can actually see. With darker skins, look for the variation of tones between different areas, and experiment with layering many colors to achieve a realistic effect.

Q&A

I find eyes and mouths difficult to draw. Do you have any tips for me?

Despite so much of our attention being focused on them each day, eyes and mouths are not that easy to draw. Although they are relatively small, eyes and mouths are complex and detailed. They are made up of many different lines, textures, shadows, and highlights.

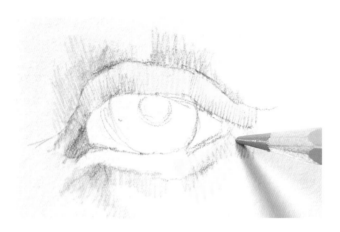

1 The basic shape of an eye is not simply made up of two curves that come to a point at either end. Look closely at the shape of the eyelid—upper and lower—and take note of any fleshy areas. Be aware of the tear duct and where the iris is placed. As always, look carefully at what you are actually drawing—don't look away from the eye and reconstruct how you think an eye should look. Shading works best across the form of the eyelid, from top to bottom, rather than following the line of the lid. This gives depth to the eye and prevents a confusion of lines.

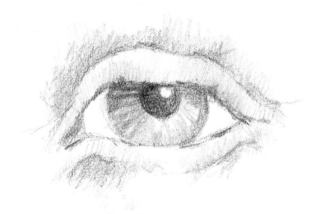

2 When drawing the radial muscles in the iris, reproduce the lines that they form. The iris is darker toward the top, in the shadow of the upper lid, and lighter below where it catches more light. There are many little planes of shadow and light where the eyelid recedes and is shadowed by the eyebrow, as well as where it curves away toward the nose on the one side and toward the temple on the other. Most important, remember the highlight on the retina, which is strong against such a dark background. This will reflect the light source of the picture.

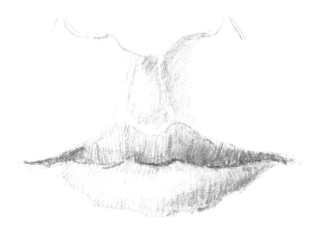

The line where the lips meet is not a steady line but a series of short shifts in direction, and this is even more pronounced when the lips are slightly parted. The top lip is darker than the bottom lip because there is less light on it—it is the top part of the lower lip that catches the light. Mouths differ greatly in shape—some people have very full lips, and others have hardly any lips at all. Always work across the line of the lips; don't follow the curve of the bow. Lips are also not just red; if you look closely, you will notice that they are often bluish or purplish, so use purple colors as much as reds. Don't forget the cleft between the nose and the mouth—and the shadows cast by it—and and the rise where this cleft meets the mouth.

MOUTHS

Mouths are a particularly important feature in portraiture because they are responsible for a great deal of the expression of the face. They vary as widely as other facial features, but they all have the same basic structure, which is important to understand.

Beginners often show mouths as flat shapes (like eyes), but they are not flat; the lips are influenced by the teeth behind them and the shape of the jaws. The sides of the mouth are like two planes, which have their highest point at the "Cupid's bow" in the center of the mouth, and they curve gently into the cheek. This curve is the reason for the steep recession you notice at the far side of the mouth in a three-quarter view. Draw your own mouth in a mirror, and practice mouth shapes by drawing from photographs or from the work of other artists. Draw men's and women's mouths, as there are usually differences—men's lips are often thinner and flatter than those of women, making a more obvious line where the lips meet.

1 The planes of the upper and lower lip show a gentle curve.

2 Seen in three-quarter view, the far side of the mouth recedes sharply and the line of the cheek can be seen.

3 This male mouth in profile shows how much thinner men's lips are.

4 When the head is turned away slightly, the fullness of the curve of the lower lip can be seen clearly.

EYES

Before you begin to consider how to "achieve a likeness" in a portrait, you should understand the basic structures—not only of the face and head but also of the individual features. Eyes are often the most noticeable and dramatic aspect of a person's face. Beginners therefore tend to give them too much prominence, often simplifying them into flat oval shapes with a circle in the middle for the iris, unrelated to the eyelids, eye sockets, and brows—all of which are integral features.

The eye itself is a sphere, much of which is obscured behind the eyelids and protected by the skull, above and below. Even when the eye is fully open, you can see only a small part of this sphere, but it is vital to remember that you are drawing or painting a curved surface, not a flat one.

Practice drawing your own eyes and perhaps those of friends or family. You might like to try copying eyes from reproductions of famous portraits, which will also teach you a lot about expression.

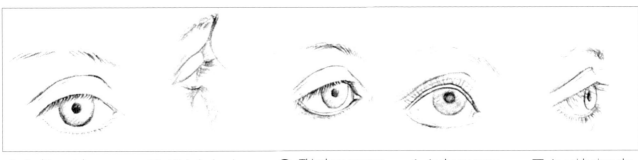

1 In this straight-on view, the top lid partially covers the iris, and a little white is visible above the bottom lid. In some people, the bottom lid will also cover part of the iris.

2 With the head turned away in profile, more of the lid and eyelashes become visible.

3 This three-quarter view shows the eye in perspective, which changes shape. Notice how much more white is visible at the outer edge.

4 As the eye turns upward, much more of the white is visible and the size of the top lid diminishes.

5 In a side view, the curvature of the eyeball is very apparent.

I find eyes and mouths difficult to draw. Do you have any tips for me? **123**

What are some guidelines for establishing the correct proportions of a face?

To get the proportions of a face correct, it may help to divide a head into thirds. The eyes are about one-third of the way down, and the base of the nose is another third down, as shown by the white lines in these pictures. Don't feel compelled to use these guidelines. The most important rule to follow, as always, is to observe closely and to draw what you see.

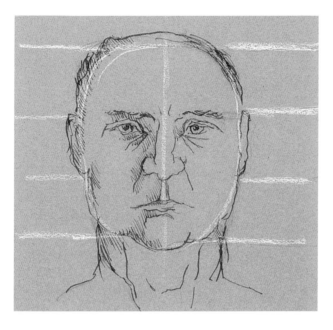

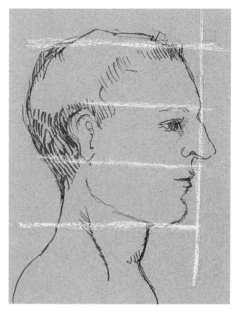

If you are including the shoulders in your picture, don't make the common mistake of drawing them too small. Similarly, don't draw the neck too thin—it is all too easy to draw a neck that looks unable to support the head that is on top of it. There is some variation from the basic pattern of a face divided into thirds, but this is never by very much.

Many artists often draw the chin too small, whether they are drawing a profile or from the front. Always draw what you can actually see, rather than simply drawing the generic idea of a face.

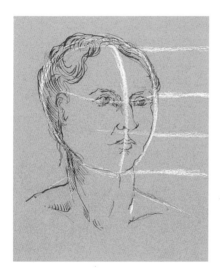

Left The easiest way to start drawing a face is to think in terms of an oval. You may find it helpful to sketch in the kinds of basic guidelines shown here.

Right Bear in mind the three-dimensional nature of the head, even if you are drawing from a viewpoint directly in front. The best way to check your picture is to hold it up to a mirror. In this way, you dissociate yourself from your drawing and see it with fresh eyes. It will show you the reverse view, which will help you to notice any problems.

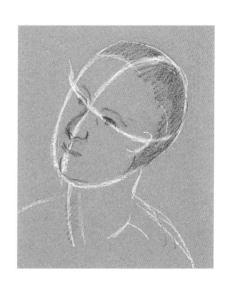

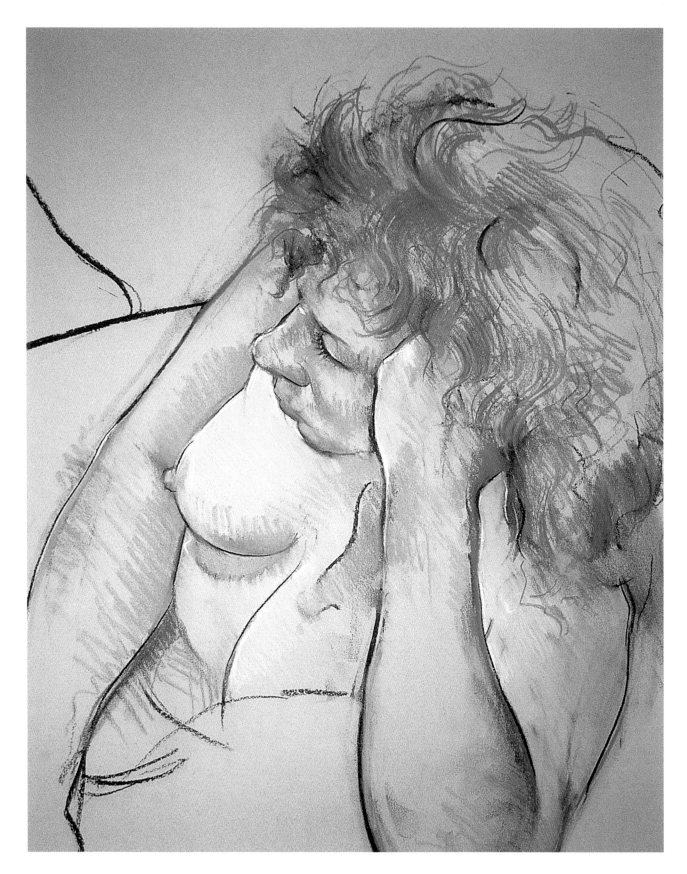

Above

In *Clare watching TV* by Robert Maxwell-Wood—notice the interest created by the
challenging angle from which the artist has worked. The face is foreshortened, and the
right forearm of the sitter dominates the foreground.

What are some guidelines for establishing the correct proportions of a face?

How do I draw different kinds of hair?

Watercolor pencils are ideal for drawing hair. Painting makes use of solid areas of color, but pencils work with individual lines, imitating strands of hair. Hair flows—it moves in waves or curls, short or long, depending on the style. The color of each strand of hair varies as it catches the light or moves into shadow, and you can copy this with pencils. Choose whether you want to work simply with dry pencils or to give a little body by wetting in the first layers of color.

Look first for the highlights in curly hair— as you would with any other kind of hair— then follow the line of the hair with your pencil strokes. Notice where the edge of the curl is blunt. Stroke your pencil away from that blunt edge. Hair forms separate clumps of strands and, sometimes, where there is not much detail visible, you can draw some solid areas of dark. Add a bit of warm chocolate to give some life to hair.

Follow the lines of the hair, as well as the changes in color of that line. With long hair, these lines are long but are interrupted with highlights. Draw a basic outline first, and then focus on the highlights. Use cream or straw yellow, bronze, and chocolate for blonde hair— brown is too strong. Tone down these colors with indigo, and create highlights with raw umber, which is slightly brighter than bronze. It takes several colors to draw one strand of hair. Always work in curves, never in straight lines, to capture the flow of the hair.

Spiky hair doesn't really curve, though a few small sections might. Look first for the highlights and think of the hair in terms of individual strands—think of spiky grass right in front of you, rather than a whole area of green in the distance. Fill in between the strands to capture the dark areas. Use French gray, which is quite a warm color, for the lines of the hair, and add a few warm touches of bronze. Go over the shadowed parts again using really dark colors, like chocolate, for the darkest areas. Go back over your drawing to include extra detail, pressing hard to capture the spiky feel of the hair, particularly where there is heavy shadow. If the color is looking too brown, add a blue color, like indigo. For the mid-tones, use a mid-brown, like raw umber.

When painting a portrait, how do I achieve an accurate likeness?

The key to achieving a likeness is to define it very slowly. Start by drawing the shadows, rather than any definite lines of particular features. Build up defining lines from shorter lines, so that gradually you create the specific structure of your sitter's face. A portrait will never be an exact photographic likeness, but it will nearly always capture some aspect of a sitter's personality. Just look closely, take your time, and draw what you see.

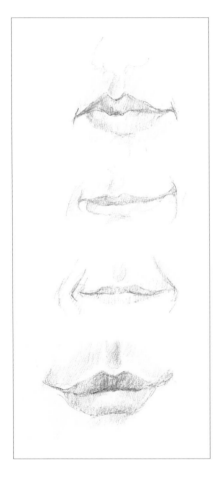

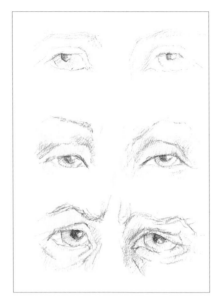

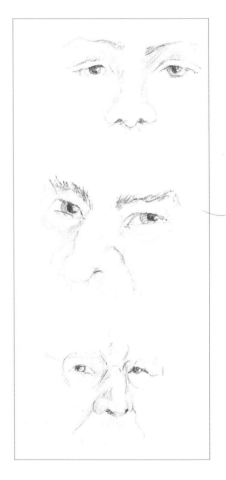

Mouths vary a great deal between people. It is not only the central line of the mouth that varies but also how much of the lips can be seen. Examine the line of the mouth to see whether it is long or short and whether its ends turn up or down. Look to see if the lips are full or thin. Define not only the mouth but also all the shadows and lines around the mouth. It is the gradual buildup of all the elements of a face that lends character and depth to a portrait.

Observe how wide the eyelids are, how the eyes are positioned in relation to the eyebrows, and how deeply set they are. Examine the shape of each eyelid individually—the right and left eyelids are different. See if there is any puffiness or if the skin around the eyes has sagged at all. Look to see how much of each iris and how much of the white is visible. Eyelids are vitally important in achieving a likeness; the color of an eye is actually a very small part of its overall appearance, but eyelids change dramatically from one person to the another. When an eye is very hooded, almost none of it is visible. Lightly draw the areas of shadow to begin with, without defining too many of the lines around the eye.

Particularly with noses, think in terms of areas of shadow rather than defined lines—contour shading works very well for this. Noses vary in shape as much as any other part of the face. Look closely for small shadows and for the colors in those shadowed areas. Resist the temptation to draw any kind of outline, but work to build up the whole from numerous short lines. Keep asking yourself questions about the specific nose that you are drawing—its shape, its color and its areas of light and dark to help you focus on achieving a likeness.

D Demonstration: **Portrait**

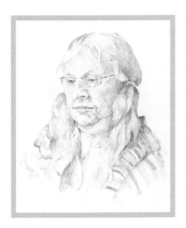

It is a good idea to start with a quick self-portrait. This can help you loosen up because you won't be anxious about having a model in front of you, or worry about their response to what you have drawn. Start with a few, small exploratory sketches before laying down faint guidelines with a graphite pencil. Next, block in the basic areas of light and dark. Slowly move toward achieving greater detail in your picture, layering realistic skin tones using a combination of colors. Leave the prominent details, like eyes and mouths, for last.

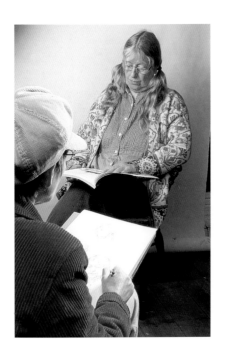

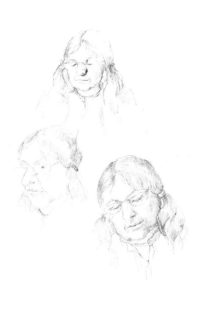

1 Arrange your model comfortably—it may help to give him or her a book to read. Side lighting makes a composition much more interesting and makes drawing it much easier. Do some preliminary sketches to decide what exactly to include in your portrait. For example, you may find that the sitter's book doesn't help your composition, so leave it out.

2 Spend 20 to 30 minutes doing some rough sketches from different angles. Aside from relaxing you, this can help you to decide which pose you would like to use. These rough sketches may also change your attitude to your subject and stop you from working too quickly when you begin your actual portrait.

3 When you begin the actual portrait, don't spend longer than about ten minutes on the initial rough outline. Work very lightly in graphite pencil, and erase anything you're not happy with. Work within a lightly penciled border that gives you a margin all around your sheet of paper. Block in the shape of the head and the positions of the eyes, nose, and mouth in relation to one another, but keep these guidelines faint.

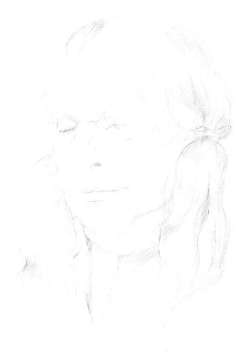

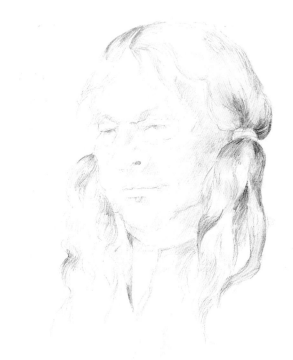

4 Indicate the main areas of shadow. Define slowly and avoid using long lines. Work on the shadows around the eyes, rather than the eyes themselves, and on the shadows of the cheek and those round the chin. A slow buildup is the best approach. Start off with good shadow colors, such as light mauves and pale browns, and then deepen them. Check proportions by holding the portrait up to a mirror.

5 Use a combination of straw yellow, burnt sienna, terracotta, and touches of carmine. Stroke the colors in and sweep them onto the shadowed areas. Leave highlights clear, and add some pinks and reds to give a good body color. Use Venetian red, darker than terracotta, for the area where the face is in shadow. Again, use a mirror to check the tonal balance.

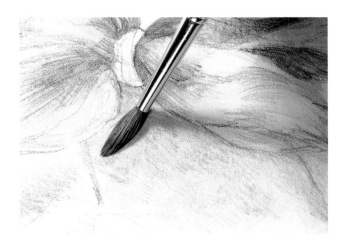

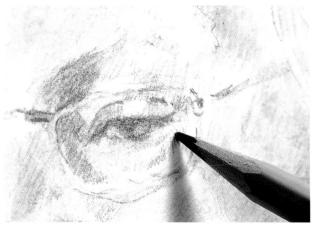

6 Use a flat brush to wet specific areas, taking care not to brush out all the lines. Keep the brush only slightly wet to "melt" the color, and dab rather than stroke. The aim is to heighten color without losing any of the carefully constructed detail. A light touch with very little water will help prevent smearing.

7 Define the area around the eye with a small amount of red using broken, rather than solid, lines. Make marginal changes only, rather than trying to define everything right away. Look at the slight lift and shape of the eyelids, and draw tiny areas at a time. This helps to capture the expression of a sitter. Put in a lot more shadow at this point, and work to bring out features that have not yet been defined.

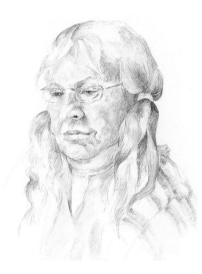

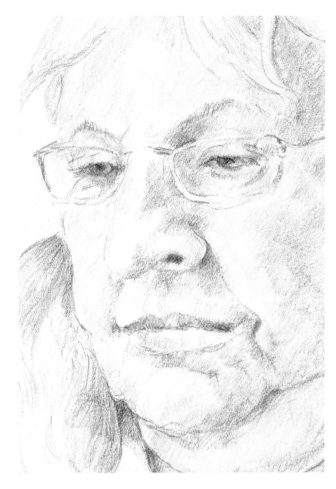

8 Use tones to build up the mouth in the same way that you would color skin, working across the width of the mouth rather than its length. Work across the stripes on the shawl, not with them. This gives a more interesting texture and captures the appearance of the shawl more successfully. Remember that you are not looking for effect, rather than perfection.

9 Use lots of tiny lines and a variety of colors to build up a portrait. Create skin tones by blending many different colors. Notice that the tones alter from one tiny area to the next as the skin folds and is shadowed or highlighted. Work hair in the direction that it flows to create the impression of fullness and length.

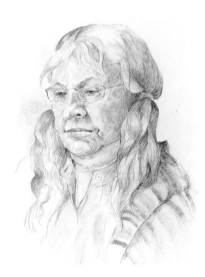

10 When the portrait is nearly complete, step back and consider what finishing touches you would like to add. You can lighten a line (by lifting color with laminate) or dim a color by gentle lifting with an eraser. Now is also the time to add final highlights, either with the tip of a wet pencil or the point of a slightly wet brush.

11 You may have to draw eyeglasses, particularly if you have given your sitter a book to read. Use bright yellow on the frames of gold eyeglasses to add highlights. Don't use too much water because a great degree of control is needed. The frames alter the color, tone, and angle of eyes. Draw exactly what you see—metal and glass give a very different kind of reflection to skin. Wet tiny areas with the tip of a brush to intensify color where necessary.

12 Even at a late stage you can use plastic laminate to make corrections—to lighten a line, for example, which you have mistakenly drawn slightly too heavily. Use the plastic in a very specific way by laying it on top of the line you wish to lighten and drawing only along that line on top before lifting the plastic—and the line beneath with it.

13 When deciding what to do about your background, bear in mind that you do not need a complete background. You may want to add some background color only on the side of the face that is in light to provide a contrast with the foreground. One way to do this is to rub pencil lines in with your finger to create a muted background that will not overpower your portrait with too much texture.

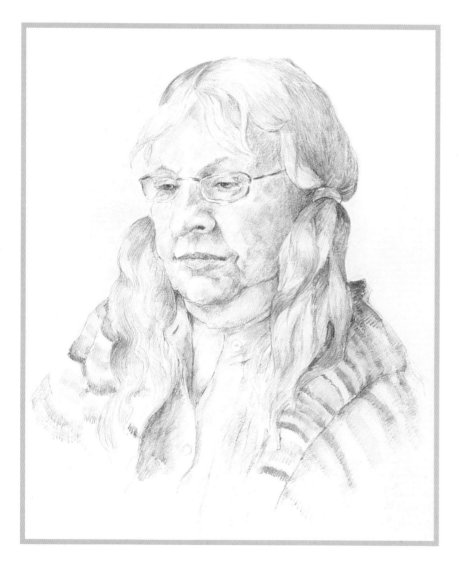

14 Check the portrait by holding it up to a mirror. The side lighting on the sitter's face makes the composition much more interesting. The colorful, patterned shawl gives some solidity and vibrancy to the bottom of the portrait.

Is there a trick to drawing moving animals?

Animals are never still for long unless they're asleep, so if you're drawing from life, quick thumbnail sketches or photographs can still be very helpful. Concentrate on getting the correct proportions and the angles of the body parts in particular stances. Focus on shape rather than form, color, and shading. Don't draw generic animals—focus on the specific animal that you are drawing, paying attention to the position of the eyes, ears, and so on.

1 The secret of capturing the posture of this argumentative seagull lies in getting the proportions correct and the angles of its body parts in this particular stance right. Correct the outline of the animal you are drawing as many times as necessary.

2 Getting the silhouettes of these yaks right helped to define them. It can be a lot easier to do a silhouette precisely because you have to focus on the shape rather than the form, color, and shading of the animal that you are drawing.

3 When drawing a dog, for example, focus on the specific dog that you are drawing, not simply the generic idea of a dog. An animal's eyes are often farther down the head than you might think. Concentrate on getting the width of the head right and make corrections early—your drawing will be better for it.

4 Change the drawing to give the dog a more alert stance. Work to get the proportions right, and don't add detail too soon. For drawings of a pet, is is very useful to do sketches and take photographs to work from. Every detail is important in capturing the posture of an animal. Look particularly at the angles of the head and eyes in relation to the ear and nose.

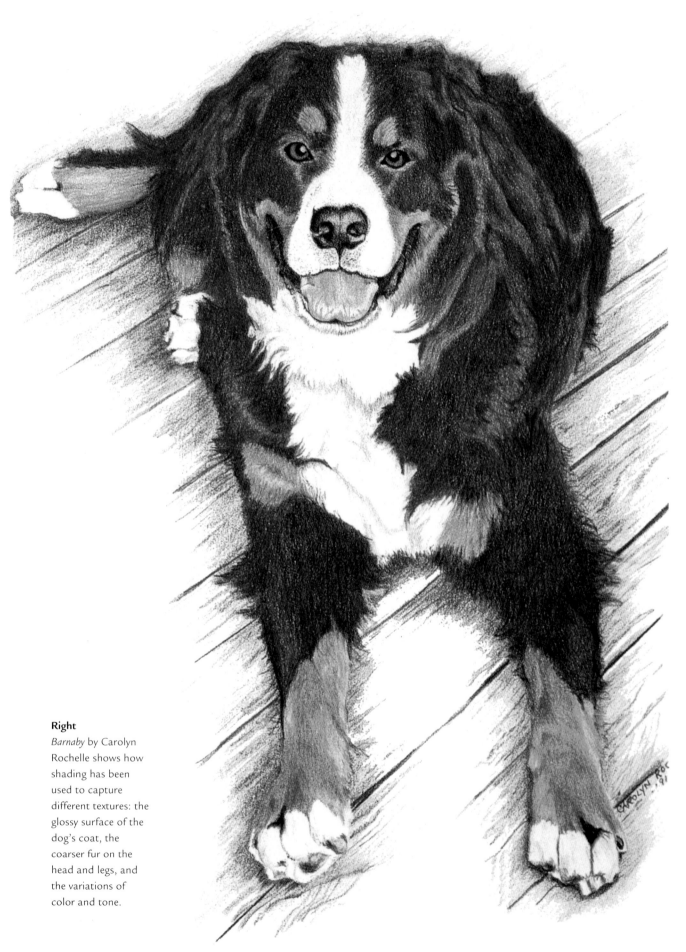

Right
Barnaby by Carolyn
Rochelle shows how
shading has been
used to capture
different textures: the
glossy surface of the
dog's coat, the
coarser fur on the
head and legs, and
the variations of
color and tone.

What are some techniques for drawing feathers and fur?

With feathers, first determine whether you are looking at the harder, shinier feathers—which show a definite pattern—or the fluffier bottom feathers, such as those on the breast, neck, and legs. Some birds, particularly water birds, have very shiny feathers, whereas the plumage of others is actually quite dull. With fur, work in the direction of the hairs, capturing the texture with short, angled strokes of the pencil. With larger animals, such as lions, this degree of texture is usually less obvious to the eye.

FEATHERS

1 Seen from fairly close up, feathers make a pattern. The spine of a feather tends to run down off center, and the edge that lies underneath a neighboring feather is darker. Follow the flow of feathers when drawing them, delicately following their direction and their pattern.

2 In this detail of a swan, what can actually be seen of the pinion feathers has been drawn. At a distance, you will not be able to make out the detail of individual feathers, but you may still be able to discern that a wing is made up of layers of individual feathers. Look for the patterns created by light and shadow to help you see this.

1 Unless you are drawing very dark fur, start with a lightly penciled neutral base color. If the fur is dark, you can wet this color, but be very careful if you are drawing an animal with a paler coat—the dark colors of wet paint could overpower the light penciling on top, which are meant to create the impression of fur. Light-colored fur often reflects a lot of light, so it is a good idea to make use of white paper emerging through the base coat.

2 Press more heavily on top of the ground color, always working with short pencil strokes in the direction of the fur. It is not always necessary to create texture all over. Use white ink or a white pencil to add highlights or if any white is needed in the fur.

ARTIST'S NOTE

If an animal is large or has very short fur, then you probably don't need to use this "fur" method. Many animals that live in warmer climates, such as lions, have thick but short fur. At a distance, this does not look obviously like fur, so concentrate on shape, rather than texture. Use smooth, carefully shadowed shapes to draw the animal. You may find it helpful to wet in the shadows.

3 Make short, angled pencil strokes to mimic the appearance of actual fur. By adding different colours in the same way, it is possible to build up the impression of actual fur.

What are the different ways to deal with backgrounds in animal pictures?

The background in a picture of an animal should suggest some kind of context—perhaps hinting at the habitat of the animal—but without overpowering the picture of the creature itself. There are basically three ways to do this: you can suggest the background with a few details of the animal's surroundings; you can sketch in the background, uncolored; or you can make the background detailed and realistic, though this of course takes time.

1 Birds are usually very small, so there is little room for maneuver. Draw the outline as accurately as possible, and then add definition by making specific markings and areas of color. Sometimes you will have to correct the original outline using the various correction techniques. There is no such thing as a generalized bird—the shape, proportions, and coloring of each bird is unique.

2 The background in this picture of a chaffinch is simple and uncolored. It situates the bird in a context but does not overpower it. The contour shading on the branches gives width, solidity, detail, and texture to the twig on which the chaffinch is standing.

3 This detail shows the textures of the wing feathers and downy feathers. Notice that the areas of color work together to define the shape of the bird. The monochrome background provides a contrast to the brightly colored bird in the foreground. Again, contour shading is highly effective in capturing the feel of the branches in the background.

4 The regal pose of this lioness, lying on a rock with one paw hanging over the edge, is very simply achieved with a few sketched background details: the rock on which she is lying and the few fronds of grass in the background. The detail does not have to go beyond the immediate outline of the animal drawn.

5 In this example, the water and the swan's reflection create a simple but effective background. The almost geometric pattern, created by the alternating blue and white pencil marks, provide a counterbalance to the drawing of the swan but without dominating it.

6 Realistic leaves and thistles form the background in this imaginary scene. Bear in mind both the kind of picture you are drawing and the time you have available when deciding on how to deal with the background. It can take a very long time to draw a naturalistic background.

What are the different ways to deal with backgrounds in animal pictures? **137**

Demonstration: **Wild cats**

Drawing animals presents the same problems as drawing people. Naturally, animals rarely pose for the artist; apart from quick sketches, you will usually work from photographs in order to capture all the details. As with portraits of people, it is only too obvious when the proportions are wrong. Take your time, and bear in mind that the proportions of different animals will also differ. Look closely when making your initial sketch; observe the position of the eyes, ears, nose, and so on.

1 Take time with your initial drawing, checking as many details as possible. Redraw a line as often as you need to until it looks right. Check that the eyes are on the same level and that there is sufficient room for the eyes, nose, and mouth. Make sure that the nose runs centrally between the eyes and that the ears are in the correct place and tilt in the right direction. With animals, the rule of thirds does not apply—the young cat's eyes, for example, start halfway down its face. Work gently, strengthening lines slowly and erasing as required.

2 Add a basic coat of color to the cats using short strokes, working in the direction of the fur. Use a light ochre and bronze for the base, but only in areas that have golden highlights. Add sepia and burnt umber to the darker areas of fur, though very lightly at this stage. Work in base coats of straw and yellow behind the cats, and add some burnt sienna and copper to the log in the foreground.

3 Use mainly dry pencils, rather than a wet brush. The fur effects require dry pencil strokes, and the background should not dominate the cats, so don't wet too much. Brush the initial coats of color into the surface of the cats to strengthen their eventual coloring. Brush the background to impart a similar feeling of solidity.

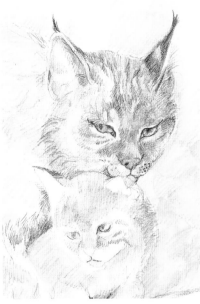 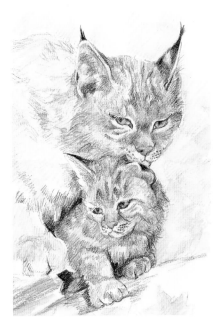 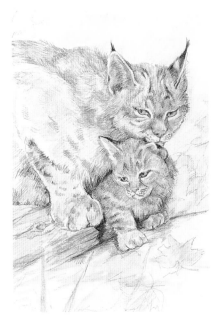

4 With animal portraits, begin with the face. Work the eyes using short strokes, concentrating on the slant of the eyes and the shape of the pupils. Use chocolate for the eventual, dark outline of the eyes and the pointed ears. If the color is too brown, tone it down with indigo and dark violet. Use cadmium yellow for the iris. Short pencil strokes build up the pattern of fur on the forehead and on the shadow areas round the side of the face.

5 Build up the darkness and shadow between the paws and underneath the bigger cat. Note the areas of white fur round the dark eyelids. Leave the area round the nose light where you'll add whiskers later. Even at this stage, because you are using mostly dry pencil work, it is possible to change your drawing by using plastic laminate to correct where necessary.

6 Add more fur to the body of the bigger cat. Fur is often shiny and it reflects light. However, you cannot add reflections as you would for a solid object. If you look at the reflection on an individual hair, there is a part that is not reflecting light. Use light violet and blue violet lake to capture this half-light.

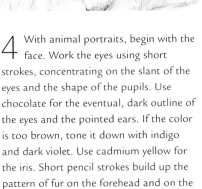

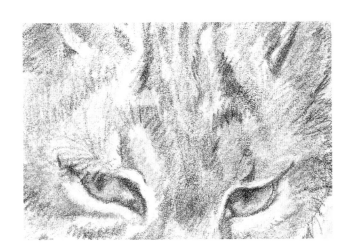

7 Build up the lines of fur on the forehead. Make pencil strokes that follow the line of the fur to show its softness. It is important that the viewer should be able to discern individual strokes, as the fractional separation of each stroke imitates the pattern of the hairs.

8 Use short, determined strokes on the cat's back to offer a broken color surface to the eye. The viewer's eye recognizes these as the kinds of patterns made by long fur. Break the edges of the area with more strokes.

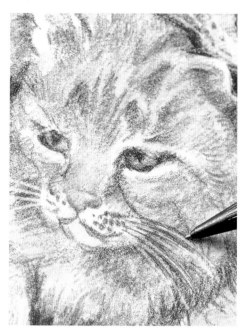

9 Overlay mauve with dark brown in the area behind the foreleg to create the impression of shadowed but shiny fur. Squint your eyes to get the correct tonal balance in the drawing.

10 The best way to deal with whiskers is to use plastic laminate to lift color off the picture in fine lines. Masking fluid is difficult to apply in fine lines, and white ink can stand out too much from the rest of the picture.

11 To make the whiskers stand out slightly more, use a sharp graphite pencil to draw a faint outline. This creates a light shadow behind the whiskers, enhancing the contrast of the light whiskers.

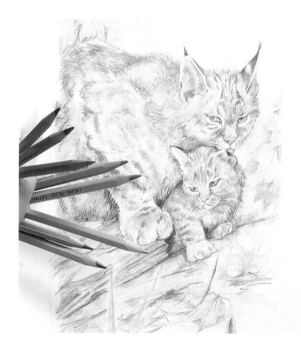

12 Create a very limited background that will not detract from the cats. Try some leaf shapes and a little color for the fallen log in the foreground. Even though it is a minimal background, build up realistic tones by using a number of colors.

13 Wet the darkest areas of the picture to add a little extra definition. Use a very fine brush to define the tips of the ears and also underneath each cat, which keeps the eye drawn to the center of the page. Lift some color with plastic laminate on the shoulder of the bigger cat to create a fur effect and to give a broken line to the chest.

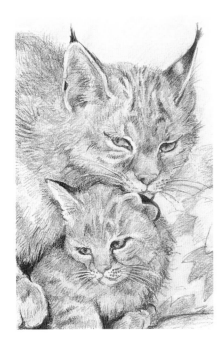

14 Because of the initial wash, the raised eyebrow whiskers do not stand out as sharply as the main whiskers. However, the fur that overhangs the eye works very well, as does the shadowed focus of each eye.

15 The rough treatment of the background leaves is in contrast to the carefully detailed work on the animals. Use plastic laminate to lift color to creat the white fur inside the ears to give a very precise three-dimensional effect.

16 Create the illusion of fur by using colors that might seem unlikely next to each other. Make pencil strokes in the direction of the fur. Use broken colors to produce shadow effects.

Conclusion

Watercolor pencils are a wonderful medium, combining some very useful qualities of both watercolor paints and colored pencils. The water-soluble pigment in the pencils means that a watered base can be created—a good surface on which to draw—while the pencils offer control and the ability to create fine detail. You need very little equipment to get started—just a set of watercolor pencils, a brush, some water and some suitable paper. Undoubtedly, there are some other materials that you may find very useful indeed, such as an electric pencil sharpener, but you really don't need much to get going.

While this book offers much in the way of helpful advice, it will be clear that the one critical lesson to learn—true for any form of painting or drawing—is to observe closely and to draw just exactly what you see. Don't approach a subject with any preconceptions; don't draw what you think you should see, only what you see in front of you. Drawing should be more of a meditation on your chosen subject than a conscious engagement with it—you should immerse yourself in looking and attempt to switch off the rational areas of your brain.

Obviously, the more you draw, the better your paintings will become. As an artist, you should have a sketchbook with you at all times to jot down visual notes on anything that catches your eye. The more you sketch, however rough your drawings are, the better your finished artwork will be.

Buy the biggest set of watercolor pencils that you can possibly afford—that way you will be sure to begin drawing and painting with a selection of the most interesting and useful colors. Experiment with different types of paper and with different ways of doing things. There are no absolutely hard and fast rules in any form of art. The really important thing is to enjoy yourself. Rather than focusing on end results, and being disappointed by what you may see as unsatisfactory beginnings, enjoy each step of the way and every drawing that you do.

Picture credits

David Cuthbert p 1; Ray Evans p 99; Judy Martin p 27; Robert Maxwell-Wood p 125; Carolyn Rochelle p 133; Jane Strother p 51.

Index